GRANT WOOD and MARVIN CONE, Artists of an Era

GRANT WOOD
and
MARVIN CONE
Artists of an Era

HAZEL E. BROWN

The Iowa State University Press, AMES

1972

© 1972 The Iowa State University Press
Ames, Iowa 50010 All rights reserved

Composed and printed by
The Iowa State University Press

First edition, 1972

Library of Congress Cataloging in Publication Data

Brown, Hazel E
 Grant Wood and Marvin Cone; artists of an era.
 1. Wood, Grant, 1892–1942. 2. Cone, Marvin, 1891–1965. I. Title.
ND236.B74 759.13 70–171166
ISBN 0–8138–1775–7

For "The Community"

Contents

Preface

It was Marvin Cone who suggested that we, he and I, set down for the record the things we personally knew about Grant Wood, and his life and work in this community. I began such a writing at his request, read it to Marvin and Winnifred Cone in their home. They approved of that writing, urging me to get on with it, Marvin regretting he could be of no physical help but wanting nonetheless to contribute in any way he could.

Personal matters broke off that writing. Then Marvin died. It seemed entirely appropriate that this "getting down" should be about both Grant and Marvin and their life in this community.

That early writing, approved by Marvin, has been incorporated in this book.

Acknowledgments

I AM GRATEFUL to the community of Cedar Rapids and to the following persons especially:

TO: John B. Turner, II, for allowing me the use of the Grant Wood scrapbook, owned by his family and housed in Turner Mortuary.

TO: Winnifred Cone, for allowing me the use of the two scrapbooks of her husband, Marvin.

TO: Mrs. Herbert Stamats, "Billie," for remembering, with her own special wit and dramatic power of portrayal, the time in the theater and Grant's own time in doing work for her family.

TO: my editors, Nancy Lindemeyer and Rowena James.

TO: Nan Wood Graham.

TO: the following Cedar Rapids people: Mrs. James L. Cooper; Mrs. John McKay; Mrs. Jim Sigmund; Mr. and Mrs. Arnold Pyle; Mrs. Robert Armstrong; Mrs. Marvin Selden; Mrs. John W. Miller; Dr. Elizabeth Halsey; Mr. Edwin Bruns (who

died during this time); Mrs. Pat Lawson, who worked with me in behalf of the Cedar Rapids Art Center; Mrs. James Day, whose "physical work" Marvin would have enjoyed, and without which the record he wanted made would never have been completed; and Donn Young, director of the Cedar Rapids Art Center.

Hazel E. Brown

Prologue

I found it interesting to watch the two boys who were on the auditorium stage, evidently painting scenery. They seemed to be enjoying themselves so much. Even as they painted, they would talk quietly back and forth, laugh, and shake their shoulders with suppressed giggles. But the painting was never interrupted.

I had no idea that 1908 day—my first at Washington High School in Cedar Rapids, Iowa—that I would know those charming young men for the rest of their lives and that those two young painters, Grant Wood and Marvin Cone, were to become famous artists and would bring unexpected attention to the community of Cedar Rapids.

<div align="right">

H. E. B.

</div>

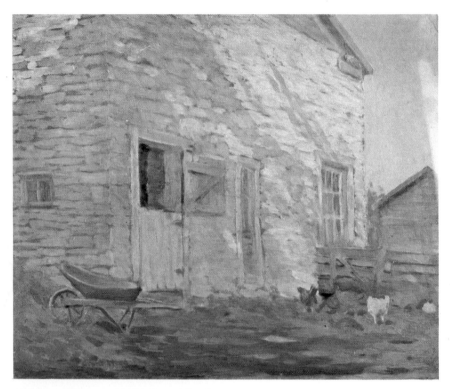

Old Stone Barn, ca. 1920, Grant Wood
oil
Mr. and Mrs. John B. Turner, Cedar Rapids

PART ONE
TWO
YOUNG
PAINTERS

Early times

Marvin and Grant first met at Washington High School, down by Greene Square and the railroad tracks, in 1906 when they were both freshmen. No two boys in appearance could have been more unlike, and their early lives were two different kinds of experiences in all respects but one—their love of drawing and art.

Grant Wood was born on February 13, 1891, in the small community of Anamosa, about twenty-seven miles from Cedar Rapids. His father's family were Quakers from Winchester, Virginia, and Grandfather Wood had brought his family by train, and then by horse-drawn wagon, to land that pleased him in the Wapsipinicon River country of eastern Iowa. His mother's people, the Weavers, were upstate New Yorkers who came to Iowa in a covered wagon in the 1840s and bought land near the Wood farm.

Hattie D. Weaver married Francis Maryville Wood, and they had four children, Frank, Grant, Jack, and Nan. While Wood farmed, sometimes both his own land and part of his father's as well, his wife taught school.

At an early age, Grant, the middle boy, liked to draw. Under the kitchen table on the farm, behind the tablecloth, he drew on the cardboard of egg cases. His early teachers at Antioch, the country school he attended from 1896 to 1901, said he had no idle time—it was all spent drawing the scenes, the structures, and the familiar animals of the farm, especially hens. Many years later, when Grant demonstrated that he knew the ins-and-outs of almost everything connected with a farm—buildings, animals, gadgets, customs—people began to realize how completely he had observed and buried within him the life around him, with no obvious effort.

When Grant's father died in 1901, his mother sold the Anamosa land and took her family to live in Cedar Rapids in a residential section of homes which still had some land areas. Ten-year-old Grant did all the chores that a boy of his age, in his state, in his time normally did. His uncle had helped the family buy a home with the money from the sale of the farm, but the Woods still had to live. Grant's cutting grass, milking cows, tending the doctor's horse, weeding gardens, and running errands were not unusual drudgery. He was normal and healthy, and he offered no objections.

In 1905, the Eastern Crayon Company held a drawing contest for school children between the ages of eleven and fifteen. In Cedar Rapids, Iowa, the winners were two girls at Jackson School and fourteen-year-old Grant Wood at Polk School.

Marvin Cone was a city boy, born October 21, 1891, into a good middle-class home on Southeast Seventeenth Street in Cedar Rapids. His family was Pennsylvania Dutch, and his father, Harry D. Cone, a prosperous jeweler with an interest in silver craft and jewelry making. Mrs. Cone, an active member of the community who took part in church activities and in other social groups, was a good homemaker and a good cook. Marvin was their only child.

While Grant Wood was being noticed at Polk School for his artistic ability, Marvin Cone at Adams School, right across the city, was getting attention for the same reason. Both boys were known to Emma Grattan, art supervisor in the school system. Later, both Grant and Marvin remembered her as being encouraging to children interested in art and drawing, and they said her instruction was valuable, for she had given them a strong feeling of the importance of design.

No teacher reported the boys as paragons. They were likable, normal boys, neither one effusive, both very affable. And they were always interested and interesting.

The Cedar Rapids Art Association was enough of a "going concern" at the time Grant and Marvin were in high school that they helped out with some of the chores. They unpacked works

4

of art sent to Cedar Rapids for exhibit, and at night guarded them to save money on insurance fees. The boys actually took turns sleeping in the gallery on the top floor of the Public Library. The one who had slept at home would stop on his way to school and throw pebbles up to the library windows to wake up the boy on guard, and then they would go off to school together.

Unpacking paintings was a dirty job, but they marveled at what appeared. For the first time in their lives they had seen fine art. When they could, they would even try to copy paintings. Marvin Cone later said that his awe and admiration for those works of art crystallized in him a feeling that he wanted to be a painter—a good painter—and there is little doubt that the unusual doses of fine painting brought periodically to the city also gave life to their desire to go abroad and see more.

This record, this experience, also rules out the assertions that the Art Association was founded on the later reputations of Grant Wood and Marvin Cone. Later admirers of the organization often remarked: "Well, you were bound to have a good organization with Grant Wood and Marvin Cone around, and their pictures to exhibit!" But the association came first, and its founding is important history in the young, rural, west-of-the-Mississippi community.

E. M. Sefton of Coe College was the association's first sponsor and his dream of a city building for art was the association's first asset. This was before the turn of the century, in the 1890s, when Cedar Rapids was a community of 25,000, growing on the banks of a bend in the Cedar River. Even then, the community had a certain cultural distinction despite the fact that no paved roads surrounded the city, few gravelled highways led into the country, and Iowa was a state known for its muddy, mucky roads, hopeless in wet weather. But Cedar Rapids had the Chicago & North Western Railroad and the city was a full stop on its main line west, just about halfway between Chicago and Omaha, something under 300 miles from each.

Being at this halfway point in early rail service made Cedar Rapids a convenient overnight stop for touring theater and musical show companies out of Chicago. This fact had given rise to Greene's Opera House, a full-fledged opera house with a

5

stage, good orchestra pit, main floor and dress circle, and tiers of boxes, two levels of seats, and a third balcony which in price accommodated the high-school and college students who used to throw pennies down onto the stage while shouting their approval. It was always sold out for one or possibly two performances, and Cedar Rapids society, dressed to the nines, moved through the lobby into the red plush and Victorian hangings of loge, box, or dress circle.

The early cultural life of the community was also enhanced by Coe College and by the University of Iowa, the first state university west of the Mississippi, some twenty-eight miles away.

Sefton, an instructor of piano and music theory at Coe, and himself a dabbler in art, was determined to add an art association to the Cedar Rapids cultural scene. And he got to work at it. Individual responses were encouraging, but support of sizable proportion for Sefton's vision was the enthusiasm of the Art Club, a society of young Cedar Rapids women. When the association actually came into being, Sefton was no longer living.

Before they began to meet in the original Public Library building at Third Street and Second Avenue Southeast, the members met around the dining room table in the Warren home and wrote personal letters to artists, asking for paintings and drawings to exhibit.

Sefton had wanted adequate and independent financial support for the association. The fund that eventually accomplished this was the one started with his promise and that of C. D. Van Vechten to give fifty dollars a year to head a subscription list. Van Vechten was a prosperous insurance man, the father of Carl Van Vechten, the writer and critic, and Ralph Van Vechten, who became a wealthy Chicago banker. Another group of men, the original Club of Forty, promised support of twenty-five dollars a year for five years. This financing was a major triumph for the very young association. When the club was renewed, the pledge time was cut to two years, and many women joined their husbands in the donations.

The Water Color Club was another financing venture. The club was made up of women who paid five dollars annually for five years. They purchased watercolors, while the Club of Forty bought oil paintings.

Mrs. W. H. Frick, president of the club for seven years and one of the best money solicitors it ever had, remembered some

6

of the members of the Club of Forty during the early years as being:

C. D. Van Vechten	O. C. Olney	Mrs. W. W. Hamilton
Robert Sinclair	George Hedges	Phillip Liebsohn
Mrs. George B. Douglas	Mrs. Minnie Lee	Wayne Foster
Edward Killian	W. L. Wick	Frank Beals
Morris Sanford	S. G. Armstrong	Frank Phillips
Mrs. Ed Smith	T. P. Rogers	Walter Cherry
Mr. Junkerman	Keith Vawter	E. J. Carey
Charles Svoboda	Dr. H. L. Walker	John C. Reid
Ralph Van Vechten	M. H. Collins	Edward Scott
(Carl's brother)	D. E. Howell	E. B. Cameron
Mr. and Mrs. Luther	John Broeksmidt	Dr. George Crawford
Brewer	Van Vechten Shaffer	Mrs. T. A. Wilcox
Arthur Poe	Issac B. Smith	Mrs. E. W. La Plante
A. L. Killian	Mr. La Tourette	B. J. Newberger
James E. Hamilton	J. M. Dinwiddie	Dr. A. W. Erskine
D. W. Warren	Col. C. B. Robbins	Ward Baker
Mr. and Mrs. W. H.	A. W. H. Lenders	John L. Miller
Dunshee	Malcolm Bolton	Mark Anthony
Mr. and Mrs. W. H.	E. E. Pinney	Sutherland Dows
Frick	Richard Lord	
T. R. Warriner	John S. Ely	

These names truly represented the small city of Cedar Rapids early in the twentieth century. On the list are the names of men prominent in the city's major industries—the Quaker Oats Company, the Douglas Starch Works, and the Sinclair Packing Company. Also represented were members of the medical and legal professions as well as retailers and wholesalers, and in fact, every name one might have seen on a store or business or in an office window in Cedar Rapids appeared on this early list of contributing members. And too, there were the professors at Coe College, the teachers of Cedar Rapids, and the leading members of the city's thriving Czech community.

No great affluence was here. Some people were richer than others, but the contributions were in what you would call a moderate range—the larger ones appreciated and the smaller ones gratefully received. The Art Association was truly a representation of the community, and the donors were, in large part, active workers in the association. It would have thrived, as it began, without the great talents and support of Grant Wood and Marvin Cone. That it did have them, and honored them, only heightens it place in the community.

7

Study for art—two ways

In a photograph of the Washington High School class of 1910, Grant and Marvin are shown sitting side by side down at the end of the second row, ready to be first to leap up for a diploma when called. Immediately after the exercises, Grant left for Minneapolis, where he intended to study wood and metal craft under Ernest Batchelder, an expert whom he admired. Marvin saw him off on the late train.

Marvin, too, would have liked to study art immediately, but his father believed a liberal education was important first, so Marvin enrolled in Coe College.

When Grant returned from the summer in Minneapolis, he worked on metalcraft in the shop of Kate Terry Loomis. He had made bookplates and sold them when he was in high school, but puttering around with rings and pins did not satisfy him. He took the Iowa Teacher's Examination and was licensed—temporarily—to teach. For thirty-five dollars a month he tutored twenty-one students, aged six to thirteen, in Rosedale, not far from Anamosa and Stone City.

Then, inadvertently, he did what no one else has ever been known to do: he went to Iowa City, literally walked right into the university without registering, enrolling in any way, nor even paying fees. Three nights a week, he rode the clattering old Interurban car the twenty-eight miles to Iowa City and the university where he painted along with the students in an art class. His work impressed no one and after three months, he quit. Of course, he received no credit, but later in life was of unique distinction in university annals for this record.

Without a permanent teacher's certificate, Grant could not teach a second year. And although he thought of another summer in Minneapolis, his idol, Batchelder, had left for another job. He decided to ask Paul Hansen to teach him carpentering.

8

Paul Hansen was the son of a successful stationer with a downtown business. Like Grant, he liked to do things with his hands and was interested in all craft work. A camera buff, Paul was experimenting with light all the time, and he eventually joined his family's business as a specialist in photography and camera equipment. But Paul was determined to be something more than just another member of "the business"; so he purchased four lots on the bluffs overlooking Indian Creek as a real-estate venture. He and his wife Vida settled in a home on one of the lots, and Paul told Grant that he would give him one of the lots if Grant would help in building houses on the other two.

This was beautiful country then, wild and unspoiled. Indian Creek wandered through the country club course and ran under a bridge at Thirtieth Street on the outer edge of the city and into Kenwood, a suburban settlement five miles from the larger city. Thirtieth Street, once it crossed Indian Creek, climbed in a wind, and the low hills with bluffs over the creek were a favorite wild-flower and bird "tramp" for school children.

Grant, learning from Paul, built his own small house with an exterior of stucco, one of the first uses of this material in the area. He loved the work, the construction, and loving work it was—exquisite construction. He was little more than a boy, but he built a home, a place for his loved ones, especially his mother.

Hattie Wood climbed up the roads, then the paths, to the house. Just fifteen yards from the Hansens, she got at her "housekeeping." Always interested in growing things, she was widely reputed to have a green thumb and those who have pictured her as primitive and pathetic did not know the Woods.

Grant kept busy making helpful gadgets, and all of them searched the countryside for dandelion greens, mushrooms, common greens, herbs, mullen leaves and even clams from Indian Creek, according to one writer. (I know Indian Creek; I am writing just one block from the bridge over it, and I doubt the *clams*.) Finding the good things of nature was not a hardship. They all liked it, making the best, which could be very good, of the growing things and wild berries. Mrs. Wood was a woman of the land; Grant was inventive, curious, and terribly pleased when he had accomplished something *himself*.

When it rained, there were corn husks to braid for chair

bottoms. And Grant, of course, could draw or paint. He was always doing odd jobs about the place or tramping out to swim in Cook's Pond—not far off—with the Hansens and their friends, the Conybears.

When, years later, it was interpreted that in his early life Grant never assumed responsibility and was not interested in working—he was even called lazy—Marvin Cone pointed out that this hither and thither sort of life was all valuable experience for Grant. Besides, what young man would ask to learn all about the construction business and build a home for his mother and sister using his own hands, his own ingenuity—and his own sense of humor? Grant managed in a mischievous mood to implant in the cement of the steps up to his door the imprint of great footsteps, like those of the giant, who according to local legend supposedly lived in the pond and stalked the countryside. It always astonished people, especially children, to see those footsteps going in, but never coming out. Marvin also recalled the many experiences, predicaments, and setbacks that Grant had in this period of his life but said that he was designing, executing, experimenting—using the strong hands and the busy mind to do many things and create many things unusual for a boy his age. For example, he helped Kate Loomis decorate her home, and over her mantel in an oak frame he placed his first signed painting—jack-in-the-pulpits in tree roots.

True, at this time he did not have a job. But he was unceasingly busy learning, exploring, and inventing, and one would be wrong to assume that the Wood family felt either neglected or destitute. And for Grant, there was Vida Hansen to paint.

Grant studied Vida while she was nursing her baby and decided to do a mother-and-child study. At first he would not let Vida see the painting because he had painted her in the nude. Eventually, however, he gave the painting to her, but she never liked it. Vida thought there was some feature distortion about it as the face lines were clear and strong, and she was embarrassed and a little angry. She knew it was good though and later she sold it. Afterward she wished so very much that she had it back. The whereabouts of the painting are now unknown, but several theories have been advanced as to what became of the work. But a relief of the Hansen's son Bobby at two years was good, and Vida kept that.

10

Grant also did a painting of his little house, making several sketches first. (Frances Prescott now owns this painting.) In fact, Grant always made sketches before he started work on the construction of a painting. At this time he dropped his middle initial, the "D" for De Volson, from his name.

In 1916, Grant registered full-time at the Art Institute in Chicago, paying five dollars to matriculate and five dollars toward his tuition. He was awarded honorable mention in the life class of Antonin Sterba; however, eleven days later he came home. Time was still due him at the institute, but he thought of himself as a failure.

When Grant returned from Chicago, he found he had been given a "C" classification in the draft. He waived the exemption and was assigned to Camp Dodge in Des Moines. During an epidemic, he became ill and supposedly was thought dead. However, he showed up at the post one day like a ghost from nowhere, with a beard and looking terribly ill. Out of this unhappiness came an "experience." Still a buck private, he was relieved of heavy work; so he drew pencil sketches of the other doughboys on brown paper and sold the pictures for twenty-five cents. Officers were charged one dollar.

Grant was then assigned to the army's camouflage section in Washington, D.C. Here, too, he spent every possible moment drawing soldiers and officers. He was even furnished with a sidecar and had entrée wherever he seemed to want to go. He really enjoyed himself, unrestricted and drawing—and the drawings won friends. He never got "over there"; 1918 and the Armistice came and he was home in time for Christmas.

Marvin's education was nowhere near as informal as his friend's. From his stable home, he went the regular route, with little protest. After his four years at Coe College, he was graduated in 1914 and entered the Art Institute of Chicago as a regularly enrolled student.

After his three years at the institute, he went right into the army, and he was stationed in Mexico with the Thirty-fourth Regiment, under General Hubert Allen. When a contest to design an insignia for the Thirty-fourth was held, Marvin Cone won it with an insignia he had made of material at hand. His "red bull"

was soon seen on some 16,000 men. Many years later, on the streets of Cedar Rapids, he was to see a detachment of the Thirty-fourth, en route to somewhere, with each man wearing *his insignia*. A less modest man might have broadcast, "Hey, I designed that insignia!" But that was not Marvin Cone, and as he saw them marching by, he was very proud.

While he was stationed in Mexico, the Smithsonian Institution was excavating heavy jars found on the heads of skeletons from pre-Aztec Indian tribes. General Allen, Major C. B. Robbins (also a Cedar Rapids man), and Marvin went on a private "dig" and found those heads, jars, and skulls. The Indians had been buried with their chins thrust out over their knees, which made the jars and heads easy to collect. This work filled Marvin's mind, and gave him an opportunity to enjoy the art and the great beauty of this country.

After several months of training in Mexico, he went to France with the Thirty-fourth, acting as interpreter for General Allen. Later, his wife and daughter teased him about the "hard time" he had in the war, riding around in a staff car with the general.

Shortly after the signing of the Armistice, Marvin was stationed for the winter of 1918 and 1919 at Montbras, a tranquil village near the city of Toul. A postwar offer by the government allowed Marvin to spend four months at the *École des Beaux Arts* at Montpellier, France, where he visited many historic sites and drank in the beauty and the dignity of the Mediterranean country and of ancient art.

He studied painting and, with a group of student-soldiers, went on a painting trip up the Rhône Valley. He had to carry his pictures in a pack on his back, explaining the series of "small" pictures which were later exhibited at home.

While Marvin was at Montpellier, he was offered a job at Coe College as an instructor in French and drawing. The receptive attitude toward art at the college was the result of Frances Mae Wolfe's course in art appreciation. Mae, a well-traveled woman, had persuaded the administration at Coe to let her start such a class, considered a very daring venture at the time. I happened to be in one of her first classes, and I still have the thick scrapbook of pictures which I compiled in her class. Through Mae's efforts, the atmosphere at Coe was a good one for art, and was to be good for Marvin, who came home in 1919 to become a teacher.

Grant, too, was teaching again. After the war, he got a job at McKinley Junior High School in Cedar Rapids where Frances Prescott was principal. "Fan" Prescott, as thousands of people knew her, was the woman who was to befriend Grant and guide him—by immediate or remote control—the remainder of his life. With her warm and understanding friendship went faith in him and a strong belief that he knew what he wanted and that his dedication would get him there.

As a teacher, Grant was something of a problem. Even in the army, he had not been subjected to arduous routine. But at McKinley, he was expected to be in his classroom every morning at a definite time. He was supposed to keep a regular record of his students and their grades. But Grant had other interests, even though he needed to hold a job and get paid. What he was presently painting was apt to engross him and keep him intent way into the night.

Fan realized this. When she could tell from the noise that Grant was not meeting his class, she would telephone him to have his sleepy voice answer her.

"Grant, you'd better get over here. Your class is raising cain."

"Oh dear, I must have overslept," Grant would answer in that quiet voice—that comfortable tone of voice.

Fan even might have to get her own car and go out to Kenwood to get him, or she might have to stave off disaster with his class, as she easily could, until he got there.

When time came for grades, Grant had none; he had no idea who got what. So Fan, book in hand, would go with him to the class and point out the pupils, and Grant would remember how each child should, probably, be graded. And often Fan stood between Grant and the school board, whose members never cared to "cross" Miss Prescott.

But Grant had tremendous assets as a teacher, too, and Fan knew it. When another teacher brought a restless child to her office, Fan had a habit of saying to the child, "Go down to Mr. Wood's class. Tell him I sent you."

When she would ask Grant about the child, he would answer, "Oh, he wasn't any trouble. I just kept him busy."

Pondering this, Fan took herself down to Grant's room one morning. The class was in session and at the back of the room, in an open space, was a round washtub that "someone" had painted green. In the tub was what looked liked a dead tree. And beside

13

the tub was a small boy who was rummaging through a pile of paper, tinsel, and other things, hanging leaves on the bare limbs of the little tree. This was his project, his work, and he was intent on it. Accomplished, it would be a showpiece of the art department.

Fan has said many times during her long life that Grant understood children and the adolescent mind. He liked children and was a sort of god Pan to them, and they loved him in return.

Fan was unmarried, tall, elegant, white-haired, blue-eyed, and Irish in eye and tongue. She had a family of her own, all of whom, I should say, do a mental salaam when they visit her, which they do often. She tells them "what," too (as she does me), and her family and friends adore this woman. We all believe that her tolerance, understanding, and faith in Grant's genius were a very great contribution to his ability to carry out his ideas for the paintings that were to bring him international fame.

During this period of teaching Grant did the dedicatory panel over the auditorium door in the old part of the YWCA, an excellent piece of wood and metal craft. And in 1924, Grant's ninth-grade art class did a frieze for the school cafeteria. A picture in the Cedar Rapids *Gazette* showed Grant and the class members around a table, working very hard on the drawings for it. The ability which he had, almost a gift, to make people want to do things for him, never raising his voice, was to be one of his charms all of his life.

In 1925, Grant finished the Mourner's Bench, which was placed in the waiting room outside Fan's office at McKinley. It was constructed by manual training students, and the faces and the motto across the top of the back were designed and carved by Grant. The motto on the bench, which today is in the Cedar Rapids Art Center, reads: THE WAY OF THE TRANSGRESSOR IS HARD.

14

Europe
and the first exhibits

In the summer of 1920, Grant and Marvin finally made their long-planned trip to Europe together. They lived in the Latin Quarter of Paris and painted the parks and streets of the city.

Marvin, a good reporter on all his trips abroad, wrote of this first European sojourn:

. . . we went to museums, and to Paris where we lived and painted all summer and had a whale of a time! Being pretty short of cash, we didn't do much travelling about. If we both had the time, I could tell you a lot of things that happened. For one thing, on the boat coming home we actually put on an exhibition of our summer's work. At that time we thought it was a novel, very smart idea, having a show in mid-Atlantic.

In one of his frequent letters home, Marvin told of buying a pottery vase for flowers in a still-life painting, and of their taking a shortcut through a cemetery on the way home. A guard stopped them, insisting that the vase had been stolen from the cemetery, and threatened to arrest them. Only Marvin's knowledge of French saved them from a night in jail.

Grant never made any effort to learn French, or any other language. Marvin said that Grant had more fun making signs and drawing pictures of what he wanted—communicating through art as it were. And Grant actually enjoyed the frequent misunderstandings. They were amusing to him, and he didn't want to learn the language and miss all that fun.

Burial places had always been an attraction for these young men, and they once took a conducted tour of the crypts of Westminster Abbey in London. Grant lingered behind to examine one of the tombs. The group departed and the guard had extinguished the lights and locked the massive doors before Marvin

15

noticed Grant's absence. The guide refused to go back, saying that another tour would be coming that way soon. Twenty minutes later, another guard found Grant, sitting on a tomb, waiting. "I knew someone would eventually come to get me out," he said.

The two also went to Antwerp, where the Olympic Games were being held, but instead of watching the contests, the Iowa pair spent their time in the art galleries, studying the works of Rubens and other Flemish painters.

On the boat coming home, the boys met a Canadian girl who had been to Paris for the summer and was on her way home. Grant liked Winnifred very much indeed; Marvin fell in love with her and she later became his wife.

Other trips abroad came later for both Grant and Marvin. After Grant's fourth European trip, he said that when he came home from France it was to "see, *like a revelation,* my neighbors in Cedar Rapids, their clothes, their homes, the pattern of their tablecloths, the tools they used. . . . I suddenly saw all this commonplace stuff as art, wonderful material." This was his answer to those, who, many years later, asked him, "How did all this start?"

In a museum in Munich Grant discovered the Flemish talent for detail that was to delight him so much. *Woman with Plant,* the first of his so-called "great ones," was the first example of what he had liked and what he had learned.

Marvin and Grant had been so proud of themselves to have had the unusual exhibit of their paintings on a steamship in the middle of the ocean. Later, Grant was to have important opportunities to hang his paintings for people to see and to buy in Europe.

But the hometown Art Association was the logical place for the young painters to show the results of their travels and their work, and the association was grateful for the novelty of showing their Paris paintings, and hoped to help the boys to sales, and to help itself as well to good work and growth.

A few of the exhibits of the 1920s, and the history of the Art Association, show us the kind of painting and the amount of painting these young men had accomplished.

16

In the absence of famous critics, or possibly by preference, some early shows were commented on by fellow artists, which was a valuable part of their education, and a challenge to their articulateness. Grant and Marvin themselves often served in this way and gained credit for their judgment and "lack of gushing" over their fellow artists.

As has been suggested some persons thought that the Art Association would not have survived without Grant and Marvin, and that it exploited them to the limit. While this is not true, it would be foolish to say that the distinction of Marvin Cone and Grant Wood did not benefit the popularity of the association, or that the constant backing and help of the association did not further, or smooth out to some extent, the painting lives of these two young artists, in particular. Indeed, it so functioned for all the young and hopeful artists, the unusual number of them, in the community.

An exhibition of paintings by Grant and Marvin was held by the Art Association for two weeks in April of 1920. This exhibition was important enough to be opened with a tea, and the art room was decorated with garden furniture, ferns, and "tall, slender vases filled with snap dragon."

Grant Wood was represented by the following works: *White Oaks, Evening Shadows, George Green Square, A Phantasy of Spring, Winter Sunset, The Cow Path, Rustic Vista, Fragment from the Song of India,* Lone Pine Inn—plans for decoration, Wall Panel in Applique—executed by Nan Wood, *Adoration of the Home*—mural outdoor decoration for Henry Ely, and Photograph of mural made for the National Masonic Research Building, Anamosa, Iowa.

Marvin Cone's paintings included the small canvases that he carried on his back through the Rhône Valley: *Golden Afternoon, Cloud Bank, On Top of the Hill, Express Clouds, On My Paris Mantel, Chilina, Luxembourg Gardens, In the Summer Air, Yellow Clouds, Evening Light, Ten-Eleven-Twenty One, Cloudy Day, Wash Day, Poplars, Fourth Street, Zinnas, Evening* (sketch), and *November* (sketch).

Two young men from the same family, George and Charles Keeler, were part of the artists' group and both had already won distinction. Charles was an etcher; George worked in wrought iron. In the very pleasant manner of having local artists "remark"

17

about the showings of other local artists, George Keeler commented on this early exhibit:

Grant Wood's work is executed with a boldness of conception and vigor typical of the advanced art that has thrown off the fetters of the set rule. His *Winter Sunset* is grim, stark reality; bleak, bare, somber tree trunks, fast-greying snow and cold fading light.

In *Ten-Eleven-Twenty One,* Mr. Cone achieves the effect of vastness of space that Raymond Johnson did in his *Silent Spaces,* but without recourse to Mr. Johnson's method of doing violence to nature. The chromatic aspect of his skies is a physical joy and he has admirably caught the spirit and feeling of space and light.

It must be understood that these artists are from Cedar Rapids. Their appreciation is a measure of our intellect. You do not know your city if you do not know them.

George was not through when he shared his enjoyment of the paintings with his audience. He continued:

We should see that he (Grant Wood) is worthy of at least a year or two of study abroad at this stage of his progress . . . there are great possibilities in Grant Wood . . . and the burden on this young man's shoulders is a heavy one.

"Cry warning to Cedar Rapids, that it may hold this young man for its own," he said of Marvin Cone. "We are accustomed to see Paradise in the next Parish and in so doing lose the things at hand." He had already, in going down the line of paintings, spoken of Marvin as "susceptive to the sound and charm of nature . . . lyric color poems . . . delicacy of tone and depth of feeling . . . caught the sensitive cadence of the coloration of air and space."

Whether it was the exhibitors, or George's serious appreciation that did it, the exhibition was extended "by popular demand," a constantly increasing attendance and a decidedly aroused interest on the part of the public.

In May of 1920, Grant and Marvin exhibited their work at Roshek Brothers department store in Dubuque, Iowa. The same exhibit was seen locally in the Tea Room of Killian's department store.

We make much, in our time, of the buying and selling of fine art by the large retailers like Sears, but almost half a century

18

ago, the "country stores" west of the Mississippi, in their new, imposing buildings, were not unaware of the attraction such an exhibit would have for their customers.

Art exhibits often traveled from Killian's to Roshek's to Younker's department store in Des Moines. It may have been two for the selling and one for the showing, but at least honest and interesting painting was given its due, and the work of these two young men was seen "abroad in the land."

Mr. Van Dyke, art critic for the May, 1920, exhibit, and the local press both named it an exhibition "of which the community could be justly proud." He also said: "Just a casual visit to this showing, even a visit or two, is not enough to grasp the essential beauty of their work. They have caught and recorded many of the paintable bits of beauty to be found around the country here, in a fresh plowed field, or rolling hill line heaved against a mass of cloud." And he made the point so often made in explanations by and for the painters, that our untrained eyes do not see the beauty as they do, we do not feel it as they do, and if there is a part to play for them in the human drama of life at all, it is as prophet and seer.

In addition to the paintings commented on by Van Dyke, Grant's work in that exhibit included: *Quiv'ring Aspen, Thirty One Seventy Eight, Old Stone Barn, The Sexton's, The Hermits, The Horse Traders, Wigglers, North Tenth Street East, A Tree in June, Fresh Ploughed Field, A Rest by the Road, A Winter Eve, The Yellow Birch, Reflection, Dull Day, January Thaw, Cloud Shadows, The Cut Bank,* and *The Scarlet Tanager.*

Marvin's work included more of his "small" paintings, done in France: *Nude, Evening Light—French Village, April First, Poplars—France, April Fourth, From Under the Trees, April Tenth, Poplars in Mist, Cloud Bank, Evening, La Bohemienne, Cream Tipped Cloud—France, Sunday Afternoon—Montpellier, Edge of Woods, Rainy Day—France, Low Hanging Leaves, Nude, Sketch, Castelaw—France, Opal Clouds,* and *Celleneuve—France.*

Another man who often served as local commentator for the Art Association exhibits was the community's well-known poet, Jay Sigmund. He was a member of the association and served at one time as a board member. An insurance broker, he sounds like a conventional person, gone on poetry. But Jay was

19

something special, and an intimate friend of Grant, Marvin, and Winnifred.

Jay Sigmund was born on a farm near Waubeek, Iowa. He dropped out of the Central City High School to take a job in a warehouse in Cedar Rapids, and then he went into the insurance business and later became executive vice-president and agency director of the Cedar Rapids Life Insurance Company.

Jay was called "The Nature Poet" and "The Poet of the Wapsie Valley" and was the author of many published poems. He coauthored three one-act plays with Betty Smith, the author of *A Tree Grows in Brooklyn.*

Jay wanted no part of farm life although his roots were deep in the Wapsie Valley he had roamed as a boy. After he was established with his family in a home in Cedar Rapids, he bought a house in Waubeek for family weekends and summers. His widow still lives there, and Grant and Marvin and Winnifred were all guests in that summer home.

In 1937, Jay died in a hunting accident. Now set in a boulder beside the old stone general store at Waubeek, where the poet listened so often to the old-timers, is a plaque in his memory. A riverside recreational park at Waubeek was dedicated in 1964 as Jay Sigmund Park by the County Conservation Board.

Jay had hunted, fished, and trapped—his main interest always the outdoors. He had an overriding curiosity about nature and a sympathy for animal life is recurrent in his writing and poetry.

Jay's poems achieved critical praise from such people as Robinson Jeffers, George Sterling, H. L. Mencken, and his longtime friend and neighbor Paul Engle, the writer and poet, who edited a memorial volume of prose and poetry selections after Jay's death. And he must have a place in the story of this community of talented people. He was a friend to them all, and a worker and contributor to the Art Association from its earliest days. His son Jim told me that he thought his dad was one of the first to urge Grant to "paint America." I do not doubt his word.

Jay was very like Grant in two ways. He was inclined to be round, and he was soft spoken. If there is a list of regional poets, Jay's name belongs high on that list, right beside the best regional artists.

20

The paintings done by Marvin and Grant during their summer in Paris were shown by the Art Association in November, 1920. Grant exhibited thirty-one oils: *Old and New, The Fountain and the Observatory, Place de la Concorde, From the Roman Amphitheatre, The Square—Chatenay, The House of Mimi Pinson, Avenue of Chestnuts, Corot's Pond—Ville d'Avray, Fountain of Voltaire, The Steps—Luxembourg Gardens, Pantheon at Sunset, Reflections Ville d'Avray, The Crucifix, Cafe of the Nimble Rabbit, The Lost Estate, By the Fountain of the Medicis, Under the Bridge, The Pool—Luxembourg Gardens, Church of Val du Grace, Lion at Luxembourg, Pool at Versailles, At Ville d'Avray, The Gate in the Wall, Gates—Montreal, The Fountain of Carpeaux, The Thinker, Saint—Etienne du Mont, Basket Willows, Street de Chatenay, Harvest Fields,* and *Bridge at Moret.*

Marvin Cone exhibited twenty-four oils: *Rue Sufflot, At the Turn of the Road, On the Mantel, Grey Day—Luxembourg Gardens, Narrow Street, A Bit of Sun—Luxembourg Gardens, French Village, Patterned Water—Corot's Pond, Sun Lighted Statue, Mimi Pinson's Window, A Pair of Queens, Reflections—Corot's Pond, Hayfield, Notre Dame—Morning, Sailing Boats, Notre Dame—Evening, Versailles, Around the Pool—Luxembourg Gardens, Sketch—Chatenay, Overhanging Boughs—Corot's Pond, Le Pont Neuf, Sketch—Luxembourg Gardens, Docks—Montreal, Misty Day Along the Seine.*

Another exhibit in 1926 showed the works of Ben Knott, Raoul Dastrac, and Grant Wood. Grant's work included a series of paintings of the French town of Perigueux, near Bordeaux, famous for its doorways; two paintings of Indian Creek; *The Old Thompson Place,* painted for the Des Moines home of Leroy C. Dunn; and *A Street in Big Amana.*

With all of the painting and studying they did abroad, both Grant and Marvin kept returning to the familiar scenes around them in Iowa. They loved the deep ravines and the high open land they found just half a mile from Buchanan School, along the Cedar River. Here was a winding stretch of country where cattle cropped—marshy, gullied by rain, patterned on summer days with shifting cloud shadows. High on the land stood an old cemetery with its crucifix silhouetted against the sky.

Marvin's *The Picture Painter* shows a comprehensive view of the valley in the background. The area was little known except to those living in the vicinity. Marvin and Grant, as previously

noted always were attracted to cemeteries. They were fascinated by the ancient stones, and Grant, at one time, found within the city limits two very old square tombstones, unmarked. He remembered them, and years later they turned up as drive and walk markers in the entrance area of Pleasant Hill, the softly elegant home that Grant helped to construct and decorate for the Robert Armstrongs, a wealthy Cedar Rapids family who established an outstanding apparel store downtown.

A young reporter, seeing an exhibit of paintings of the river valley area, wrote: "Views of the landscapes in the vicinity are well worth seeing." He was quite excited by the showing, and hoped there would be many others by the young men and their facile brushes. And he thought there should be an "art atmosphere" to encourage them, support them, and give them the sympathy they needed. (Some wag, reading this, suggested that members of the Art Association stand on the street corners handing out papers on the association's early history and accomplishments.) And he made one comment which even the great critics of later days never thought up: "They [Grant and Marvin] are depicting the 'Great American Backyard' as their hobby."

Indian Creek, of course, was another favorite painting site, and the Wapsipinicon River, the small settlement of Quasqueton, the old stone quarry a few miles from Anamosa were not the flat prairie land that easterners often assume Iowa to be. There was picturesqueness abundantly at hand.

It was not difficult to get around to all these places: this was the time of the automobile, but not yet the "mad speed era," and not yet the era of general movement in car rather than on foot. Grant was never car-mad, as young men his age were beginning to be. For him, when he was finally able to have a car, it was merely a convenience. He carved and painted a hand, and stuck it out the window when he wanted to signal a turn. He loved to show it off, and the whole community became familiar with it.

Both Grant and Marvin, all their lives, had to combat the public's idea that they took their paints and easels out to these places, saw something they liked, and set about to paint it. Marvin, especially, found people in wonderment that he could paint clouds when they were in motion. "The reason I don't have to worry

22

about cloud movement," he said, "is that I do all my cloud painting indoors!"

Marvin thought that when you are young and learning to paint, you go out sketching. After you have done a hundred things from nature, your serious painting—your professional painting—is done in the studio—the place for really creative work and the quiet place, where one can do solid, uninterrupted thinking. When you sketch outdoors, you get the outlines, the idea, the possibility. If one tried to do serious painting outdoors, one would see too many things and have too many distractions.

Grant said that the first look, the first impression you get of something to sketch is the "bones" of the final painting. You may work them over in your mind many times, planning and designing with the "bones." Once what you have in mind is well organized in your head, then you do your painting in the studio. You may make many sketches, and when you have done the best you know how, then you begin to paint.

Another expression that had to be explained all through their lives, in casual discussions and in teaching, was that an artist was not like the lens of a camera; he had no intention of producing *literally* what he saw. He interprets it and he uses the idea, maybe those "bones," but it is something that has caught his imagination, and the painting is his own personal "interpretation."

Both Wood and Cone used to laugh explosively at the idea of their setting up easels in downtown Cedar Rapids, in the midst of traffic, to paint. "It would be jail for us in short order!" They had found that painters and their easels were so common in Paris and in the French countryside that one gave them no more attention than he would a fire hydrant.

But these artists and their painter friends roamed the environs of the city and the surrounding countryside, and their work was shown here often. Exhibiting in one's own community and home town, by a well-run and interested organization is one thing. But how would these young men get *out* of their own community, reach people outside the county, or even outside the state? We can thank the Ladies! After all, it was their century!

The Iowa Federation of Women's Clubs took the lead. The ladies held local exhibits and sponsored regional and state

exhibits—beginning in the late 1920s. The federation was no "big city" operation; it was of the "elite" in the sense of active housewives, farm wives, and other civic-minded women working for the community and the state. They represented almost every community in Iowa larger than a road crossing.

The cooperation between members of the federation and the universities and colleges was very effective. The state schools and the small colleges of Iowa opened their new unions and lounges to the federation's exhibits. At Ames exhibits were arranged at Iowa State College (now Iowa State University) Memorial Union. The University of Iowa eventually had an art building, where exhibits were housed. The state school at Cedar Falls and the small colleges—Coe, Cornell, Grinnell, and others—all benefited through these showings. The federation was, indeed, a state power.

Another organization which did a great deal was the Iowa Artists Club. It was founded by a group of Iowa artists with the objective of the "promotion of the Fine Arts, the holding of exhibitions of members' work and that of other artists by invitation, from outside the state." In fact, the Iowa Artists Club was the only organization that generally sponsored the work of all the artists in the state whose artistic ability was regarded of sufficient merit by the elected jurors.

In the opening exhibit of the Iowa Artists Club in November, 1931, in Des Moines, Marvin Cone won the coveted Thompson Prize of one hundred dollars. The award was "at the jury's discretion, for a work of consummate distinction in any medium." Large, decorative *Thunderhead* got it. He also showed *Still Life with Jug* and *Corner of My Studio,* which depicted an old chest of drawers with an assortment of jugs and the whimsical addition of his daughter's black and white kitten.

In Iowa, a local or state fair was one place where a large number of people would certainly see fine art. Backed by the Iowa Artists Club and the energetic women of the Federated Women's clubs, art exhibitions, and later, art salons, were held at the Iowa State Fair in Des Moines, the All-Iowa Fair in Cedar Rapids, the famous Cattle Congress in Waterloo, and many county fairs.

During the days of these early exhibits, Marvin and Grant also took part in "Living Picture Festivals," touring Iowa and adjoining states as assistants to the supervisor of art in the public

24

schools. They made all the backdrops and properties and served as stage directors. Once, in Minneapolis, Grant posed as a bas-relief, with one side of his face painted green. With little time to pack up and leave, the vivid makeup was forgotten. Only the amazed and horrified occupants of the street car brought it again to his attention.

The question of exhibiting was discussed by Grant in an article for the bulletin of the American Women's Club of Paris in September, 1926. Of the one-man show, he wrote:

. . . great for the exhibitor if he can convince the judges he is worth this much space. The proprietor must look at it from a commercial point of view. The artist should be very well known to draw a crowd. The lucky painter who gets a gallery has a chance to make his own arrangement to best show the purpose he is driving at . . . having a room to himself, he doesn't have to consider the rights of other painters in his hanging. . . . The painter's personal evolution can be found in a well built-up one man show.

The Salon is a battle, rivals showing their strongest work and sorry to him who is grey or subtle. So one picks of his work on the "best" or rival basis. If he lands his work in strong color and contrast, he is lost. And if he lands in a group of dull painting, even worse . . . rough justice in the survival of the fittest, but the most spectacular work tends to win.

A painter can't complain, for if all did, there would be no exhibit. If proper space is given each picture, the viewer has a better chance of isolating it in his judgment. White space is very hard to get—precious to the painter and the advertiser alike. A colored wall is a disadvantage. A warm painting can practically disappear. The ensemble itself should be considered—a hodge-podge is defeating at once. Skill, often shown, in the grouping and hanging, can do a lot for every exhibitor.

The interior of the Parthenon is an example of a very bad arrangement. Intended to be part of a decorative scheme of great proportions, it is a badly mixed exhibit. As it stands, it is a conglomerate of greatly enlarged easel paintings. There *are* some few true mural paintings in the group—Purvis Chavannes—and it is a pity that it could not be a one-man show by a mural painter of his stature!

A one-man show can be monotonous! Too close confinement to one idea in subject matter, too limited a range in technique, or even too standard a size in his paintings. And he doesn't get the massed drawing power to his show that a Salon gets. This is a real disadvantage.

Grant preferred the ensemble way of exhibiting and outlined its advantages:

25

It can have few artists working on not dissimilar lines. The group has more friends to assist in advertising the show, to the benefit of all. It is easier for a group than an individual to obtain a gallery. Changes and shifts in the hanging can be easily arranged. There is little danger of monotony . . . individual personalities, but not too much contrast, for the group is selected from among people displaying sympathetic tendencies. Hence, the group idea seems to be the best, the most ideal showing that is to be had.

Marvin Cone, who had almost a quarter of a century of exhibiting after Grant died, was often asked how the two got into an exhibit in the first place. Did they just send paintings to whereever they learned there was to be an exhibit? Marvin explained that the Iowa Artists Club and the Women's Club organizations, and their own Cedar Rapids Art Association, usually had notices of the dates of exhibit, place of receiving, especially if the exhibit was a general one, open to all artists. The painter, of course, had the expense, and work, of boxing, packing, protecting, and insuring his paintings for their traveling and absent time. It was a serious matter all-around. And there were limits. The Iowa Artists Club and the Federation of Women's Clubs often sponsored annual, semiannual, or biennial exhibitions only for painters in Iowa, Iowa and Nebraska, or the five midwestern states. Davenport, for instance, had exhibits limited to artists along the Mississippi.

Open exhibits, however, were chancy things, for literally *thousands* of painters might send entries. As I remember one open exhibit, there were 6,000 paintings received, and only some 200 could be accepted, and this involved tedious prejudging. When Marvin got into an exclusive exhibit at all, when he was one of 50 out of 300 to be accepted, he had *already* won an honor. If he won any prize on top of that, he had done very well, but he won many firsts, and sweepstakes frequently, and usually at least honorable mention. This was also true of Grant with his everlasting blasting of an exhibit to pieces with the power he had with his paintings, and the "great ones" upset the critics, the reviewers, and the people and created a minor art war.

A good press, a good review, was always manna to the hungry painters. In Cedar Rapids, the old *Republican* and later the only newspaper, the Cedar Rapids *Gazette,* were considerate of the

Art Association and the young painters. Through its editor, Verne Marshall, it supported the association and let its young and good art reporters loose on the goings on.

These reporters were all fair, and if strongly critical, perhaps they were so for fear of being too complimentary. Three reporters in particular, John Reynolds, Adeline Taylor, and Donald Key, would have done credit to a metropolitan art column. Adeline was a student under Marvin Cone at Coe and a painter herself. Don Key was also a painter, and even showed up in an exhibit or two, away from home. He went from the *Gazette* to the Milwaukee *Journal,* where he heads his own art column.

When I say "let them loose," I mean they did not seem to be restricted in space, and many of their accounts—like Adeline's of Stone City—were small pamphlets. They were, quite naturally, more accurate about the details of the lives of Marvin and Grant because they lived in the community and *knew.* For that reason alone, their critical comments were often preferred to the "researched" lives and incidents handed out by far-off critics and reviewers. If all the eastern writers were correct, Grant Wood lived a dozen totally different lives from the time he was born!

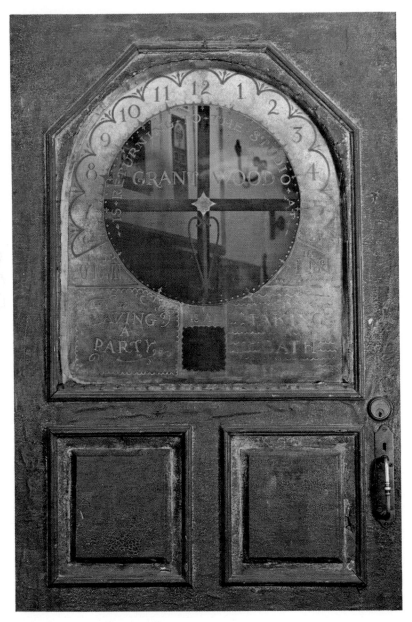

Studio Door, No. 5 Turner Alley
Mr. and Mrs. John B. Turner, Cedar Rapids

PART TWO
"GREAT
POSSIBILITIES"
GRANT WOOD

No. 5 Turner Alley

In the early days, John B. Turner had his undertaking establishment on the low bluff just above the river on First Avenue Southeast in Cedar Rapids. His son, David, was a likable young man, who in the company of a friend named Skinner played pranks and made merry around the town. David, it was assumed, would "go into the business."

Those were the days when funerals were conducted in people's homes at great inconvenience. When Dave entered the business, he believed that the idea of the funeral "parlor" or the complete "funeral home" was the way to give the family privacy, accommodate all the relatives and friends, and literally lighten the deep black of traditional mourning into warmer, more human tones, with more real affection.

We know all about these matters in this later time, but it was a new idea then, and young David Turner was in front of the change. Imaginative, energetic, kindly, and enterprising, he realized that his community was growing and that the funeral manners of his father's day were going to be different, too.

In furthering Dave's idea, the firm purchased a fairly sumptuous home of an earlier day on Third Avenue, where the great elms still marched up Seventh Street as they had grown when this was an outpost. This home had been owned by the Mansfield family and was known as the Mansfield House. Its distinctive characteristics were its base of red sandstone which had been shipped down from the northwest corner of the state; its upper clapboarding, painted green; and its third-story turret. On the first floor, it was distinguished by double, rounded plate glass windows, the outlook of the front parlor. Later the house was called the Red Hen, and it did look just like that.

The town kept growing, however, and Dave was discovering

31

that, too often, many visitors to the services were standing outside because the chapel would not hold them all. More and more people liked the idea of having funeral services away from home. The Mansfield House, already butted by the business district, had become too small.

On the corner of Second Avenue and Eighth Street, across the alley from the elegant Masonic Library, was the red brick Georgian house that a Douglas family had built and a Sinclair family had later bought. Known as the Sinclair House, it was considered one of the city's most beautiful and elegant homes, and it was empty. The Sinclair House became the next Turner Mortuary.

Not even John Turner II, David's son, knows exactly how Dave Turner and Grant Wood got together. But get together they did. After all, Dave was looking for help to decorate his new mortuary, and although Grant Wood had no reputation at this time as a decorator, Dave knew he was a young man with ideas about many things besides painting. Evidently, Turner called upon Grant to help with the job of turning Sinclair House into a mortuary.

Grant, just returned from Europe and teaching at McKinley Junior High School, had the old problem of finding a home for his mother, Nan, and himself. Dave suggested that if Grant were interested in doing over the big open space over the mortuary garage, once a coach house, it might make a very pleasant place for his family to live.

With the help of some students from school, Grant used every angle, every slant, and every aspect of this empty, open, high-in-the-middle loft and arranged it for his convenience. The steps going down on the east side led to a door which Grant personalized by devising and installing a meticulously painted clock which indicated his whereabouts and the happenings at his studio. Photographs of this original door, with its "Clock of Indications," appeared in later exhibits of his paintngs.

Bruce McKay, an architect, builder, and friend of Grant, helped out, but the ideas were Grant's, and most of the work at 5 Turner Alley was done by Grant himself. As Marvin said, "He

32

had beautiful, strong, competent hands, which learned to do many things for him."

Grant installed a pullman kitchenette with a serving window which was shuttered when not in use. The shelves above the counter were just wide enough for plates, cups, and glassware. Under the eaves, he made a drawer for silver, a tin-lined one for bread, and in the extra space, he constructed a small compartment for dish towels. Over the compact sink at one end of the kitchenette he placed a skylight. The electric range was on the service side of the kitchen; the refrigerator opposite on the wall side was sunk into the wall and concealed on the other side by a long, narrow cabinet in the bathroom. The cabinet continued from the refrigerator line to the bathroom door, with the empty space on the bathroom side a linen closet.

In the bathroom a sunken tub averted the danger of bumping into the eaves that getting into a normally placed tub would have produced. Back of the tub were green tile and a sea-green wall for which Grant had ideas—never developed—about jellyfish and sea urchins.

Over his bed were two long, polished walnut shelves where Grant kept his rolls of canvas. For ventilation in the summer and heat in the winter, he had a wide arch cut through the wall above the studio-living room radiator. Then he made a removable panel that fit snugly into the arch on the bedroom side.

Under the eaves he built a big closet with doors that folded back to show a set of five drawers attached to the back of each door. In the west end of the studio, under the eaves, long cupboards rolled out to make twin beds, and they were also used for canvas storage. And so it went everywhere—Grant using conveniently every possible bit of space and being practical, inventive, and rather mischievous at the same time.

The original "Grant" floor was squared-off, six-inch white pine, and the squares were painted blue, green, orange, and red in a giant checkerboard design. (Exhaust fumes from the garage below eventually made it necessary to lay a new floor over the pine.) The pierced brass covering of the radiator under the paneling in the room and the half-bushel basket over the hood of the fireplace were also distinctly Wood "touches."

Grant turned what had been called a "decrepit attic" and a "smelly hay loft" into what was widely acknowledged to be a

33

place of comfort, convenience, and beauty. It was here that Grant worked as a decorator, directed the artistic life of Cedar Rapids, and began a community theater. And it was here that his most famous paintings were done. A fire in January, 1932, resulted in several changes in 5 Turner Alley. In repairing the damage, the ceiling was raised and a storeroom was made into a separate bedroom for Mrs. Wood.

When the new mortuary was finished, Grant had paintings stacked up in Turner Alley, and Dave suggested that the "stack" be brought down and hung on the mortuary walls. There, he felt, people would see them and might be prompted to buy. At least, Grant's work would be, in a way, on exhibit. Grant, too, thought it a good idea.

With this experience, and with a constant desire to help Grant in his work, Dave took Grant and some of his paintings to a mortician's convention. At this meeting Grant talked about his work in Cedar Rapids. Reputedly, Grant could charm the birds out of the trees, and as a result of this charm, Dave's persuasion, and the merit of the paintings themselves, there were more painting business and more income for Grant. Dave was pleased, and the morticians who bought paintings from Grant were never known, to my knowledge, to think they were "put upon." (I know of one who said that he could never thank Dave enough for the opportunity, adding "Do you know what my Grant Wood is worth now?" And that was decades ago!)

In these days Grant's mind was preoccupied with his painting. Just as he unintentionally failed to meet his classes on time, he also often forgot to pay attention to his bills. He always intended to pay them as soon as he got some money, but when the urgent notices came, Grant went to Dave Turner. Dave always advanced the needed money and saw to it that the tradespeople were placated. If it were a very serious matter, such as a lapsed insurance policy, or some very great pressure for payment, Grant might call up Dave, and Dave would contact John C. Reid, the influential president of the National Oats Company who had always taken a special interest in Grant and Marvin and their painting. Then the three men would meet late at night at Travel Inn (popular downtown spot) and go over the situation, seeking the best possible solution. With a keen sense of humor and great stories to tell, John Reid was the city's favorite public

34

speaker and often had a chance to say a good word for Grant.

Grant always wished there was some way to pay back Dave and John and also Fan Prescott, who was always ready to stand at bay for Grant. He always intended to. Although he was accused by some of being a "moocher," his friends never believed this of him. When he did have money, he did pay them back.

Grant's embarrassment on one occasion when he needed money gave Dave an idea. He told Grant that if he wanted to sell the paintings that were hanging in the mortuary, Grant could name his price and Dave would buy the lot. It was up to Grant. The idea suited Grant perfectly. He was happy to have the money, and Dave, who had grown fond of those paintings, was glad to own them and to know that they would be staying at Turner's. They were all Grant's very early work, and many of them were local scenes so familiar to Dave.

Later, Grant was told that David Turner had grabbed his work, knowing that it was going to be worth a fortune. This is not true. The sale happened exactly as I have written it here. The proof is that the paintings are still in the mortuary, just where they have always been. Neither Dave, nor any member of his family, has ever parted with one of them—and they have had some spectacular offers.

At one time, a grateful Grant told Dave that he wished he could do something for him—to repay him for all his help. Dave said, "You can, Grant. I'd love it if you would paint a portrait of Virginia (Dave's daughter) while she is just at this age. That you could do for me."

I remember Grant as he told Mary and me that he was so pleased that Dave wanted him to paint Virginia—"As she is right now," he said. Events, unforeseen, made it impossible for him to do this one thing he wanted so much to do—and certainly would have—had it been possible.

Some fifty Grant Woods now hang in the Turner Mortuary, about forty of them included in the original purchase, the others bought by Dave during the years that followed. Among them are:

The Old Fire Engine 1886—This old Silsby was last used at a packing house fire. Because there was no wood available, slabs of bacon were used to fuel its boiler. They burned with such heat that the boiler burned out, and the engine sold for fifty dollars as junk. In Silsby days, the "best people" belonged to the

35

fire companies, and there was great rivalry between the different hose companies.

Going Shopping—The A. B. Masons going to Osgood Shepard's store, where they would exchange potatoes for dress goods.

Little Muddy—In this painting is included Cedar Rapids' first church, built in 1849 on the site of the old post office building.

The Old Sexton's Place—Front yards are prim and precise for a painter; it was backyards that Grant found interesting.

Misty Day, Paris—This small sketch of the fountain in the Luxembourg Garden was stolen from the Art Association's gallery in the Public Library, but later returned with the explanation that it had been borrowed by an art student for sketching.

Fountain of Voltaire—Done in the village of Chatenay, where Voltaire was born, it shows an old woman drawing water at the fountain.

Square—Chatenay—A typical French village square with its shops and shade trees is the subject of this early painting.

The Cow Path—A typical Iowa scene, and a red barn, presents a striking contrast in theme and treatment to the European paintings.

Ville d'Avray—This work, a combination of sunshine, pathway, and shadowy pool, was painted at Corot's Pond, a great rendevous for artists from Paris who sought inspiration from the pond immortalized by the great Corot.

A Studio Corner—Done in warm, bright colors, it shows a corner of Grant's studio in Turner Alley.

Studio House

During the remodeling of the Sinclair House, Grant had another idea. In the September 2, 1926, issue of the Cedar Rapids *Gazette,* the community was informed with great fanfare that a Latin Quarter was to be opened in Cedar Rapids. The account read:

> Grant Wood and Edna Barrett Jackson, a well-known soprano soloist in musical circles, have between them developed a unique project which will develop all of Turney Alley into an art project to advance the cause of all arts in Cedar Rapids and surroundings, to regulate and encourage continued study and application thereby, to develop the scholarly comprehension and technical command which enriches the individual and encourages the cultural growth of the community. Its Motto: Study and Teaching; Interpretation and Inspiration; Cooperation and Mutual Development.

Turner Alley, east of Grant's No. 5, was an alley of old barns, some well-preserved buildings, and "atmosphere," and and this was the area Grant proposed to convert to studios for music, art, drama, and dancing. A new building, with overhanging balconies, wide windows, and sloping roofs, was even contemplated. This was to contain a recital hall, art gallery, club rooms, and studios. Grant also envisioned a paved courtyard.

The fertile mind of Grant Wood and the companion mind of Edna Barrett Jackson, an alert and ambitious woman, had gone all out to devise plans to make the short alley a renovated and constructed place for artists, a continuation of the already famous 5 Turner Alley. Edna Jackson had even lined up possible participants and/or occupants, and among those encouraging or assisting Grant were John C. Reid, Henry S. Ely, a well-known realtor, Dave Turner, and J. B. Farquhar, of the *Republican* staff.

The Fine Arts Studio Group which, according to Edna, was

composed of fifteen of the most promising musicians and artists in the city, included: Ernest A. Leo, dean of music teachers in the city; Bernice Ladd, teacher in a well-known school of expression in Chicago; Bonnie Fisher, a dance instructor from famous schools of dancing in Chicago and New York and the wife of actor Gordon Peters; Ralph Leo, talented singer and son of Ernest Leo; Florence Hromatko Taylor, violinist of symphony quality and a member of the well-known Taylor Concert Trio; and several others.

Edna herself had been very successful in her musical work and had given performances in churches, music clubs, and on the concert stage. She was highly regarded throughout the community for her various abilities. John Reid and Dave Turner furnished their promotional know-how, and the talented people on Edna's list cooperated. It looked like a splendid idea, and Grant was on his way to achieving a cherished dream.

The group members were not "colorful Bohemians" of traditional imagination, but serious and hard-working people. Good taste guided all the planning and the performances. The term, "Latin Quarter," was not exactly to Grant's own serious good taste. But the press "gave it the works."

While plans were going forward, but nothing had definitely been accomplished yet, the Turner firm moved into the Sinclair House. This left the old Mansfield House empty. And that led to another idea, I don't know whose. Dave, however, offered Mansfield House for use as an artists' studio and colony, and Grant enthusiastically set about looking for talented tenants.

Several years before, Mary Lackersteen and I had opened a gift shop in one of the apartments in the old Preston House, a red brick building of plain design, but considerable dignity, on First Avenue, about a block from Coe College. This area represented the affluence of earlier days, but the business district by then reached to within a block of the old home. In May, 1924, we hung our little sign—a boy on a hobby horse designed by our friend Otto Ambroz—from a post near the sidewalk.

At this point, I was a silent partner in Hobby House and retained my job at Penick and Ford, Ltd. Mary, a graduate of the School of Civics and Philanthropy of the University of Chicago, had come to Cedar Rapids as director of city playgrounds under the control of the Social Welfare Council. As a welfare secretary

38

for my firm, I was a member of the council and became acquainted with Mary when we both worked on the program committee. We wrote a play together and produced it for a dinner—a program of the council. When the city took over the playground system, Mary decided to stay in Cedar Rapids and open a gift shop.

Our opening-day tea brought out a good crowd to the small shop, actually the living room of Mary's quarters. Among those who came to wish us well and view the merchandise we had bought in New York and Chicago—now so prettily arranged—were Grant and Marvin, whom I, of course, had known since high-school days. Grant, in fact, had approved of the soft gray monk's cloth draperies we hung in the tall, slightly bayed windows of the back parlor. As they left, Grant suggested pleasantly, "You'd better refill the nut dish, Mrs. Douglas has kind of absent-mindedly been feeding her two pekingese." We started Hobby House guest book that day, too. On the whole it was a satisfactory day, and our assisting friends stayed on for a celebrating supper.

The shop went on its way in a small fashion. After two years, however, it was obvious that the apartment's living room was not large enough, and besides we did not have enough storage space for the merchandise which should be stocked. Mary and I were thinking about this, lost for an answer—downtown rents were beyond us, even if space were available—when Grant walked in.

He looked around, nodded, lighted a cigarette, got settled on his feet, grinned at us, and said, "How would you girls like to move?" He stood there, pink-faced, cherubic, grinning widely, and we just looked at him.

"You know Dave has moved into Sinclair House," he went on. "Well, that's done and he has cleaned up the old Mansfield House and turned it over to me to fix up as a studio and teaching place for artists, a sort of Studio House. I'm terribly excited about it, and I have it all planned out. I have just about all the space rented except the lower floor, the long room where the entrance and the chapel room used to be. I thought right away of you girls! I knew you were getting crowded here, and this new place is much nearer town, right on Third Avenue, and I pictured how you, Mary, could live there—as you do here—and have the shop, too. I've figured it all out for you, and the boys there think it would be a wonderful idea. Your shop would look even prettier

39

there. Good light, janitor service by the house, and well, I think you would be a good influence in the place—it would be good for the boys to have you downstairs."

Mary snorted at that. Years later, Grant was to paint a work he called *The Good Influence,* and I'd hate to think that we looked as saintly smug as that character did.

Will you come down tomorrow morning and look at it? I know you'll like it. And the rent is very reasonable. I'll meet you there."

The next forenoon, we stood in the doorway—the French doors open from the hall to the chapel of the former mortuary—and looked at the dark woodwork, dull wall color, and the little stained-glass window on the outside of the alcove over the fireplace.

"And where did you plan for me to live?" Mary asked.

"Mary, the old bathroom—all marble—is right back here, all yours, and the old kitchen, white-tiled, is here with connections for gas, electricity, and water, and this little room here with the sliding door used to be the family room for the mortuary. I figured that if your furniture were out in the shop, as you have it now, you and your personal things could get in here. It's private—you can keep the sliding door closed. The whole back of the house would be yours then."

"But it looks so dingy and dirty, Grant."

"I know your cleaning woman could give the floor a good washing and waxing, and it would look much better—it's a good hardwood floor. And I have an idea about the walls. I think if I stipple over them, it will lighten the room and make the walls look like new. And if you approve, I'll be glad to do it. And, Mary, I think the dark woodwork, polished down, and the dark floors will make good background for all your shop colors."

"When would we move?"

"In about two weeks. The other occupants are planning a sort of opening, but they'll wait and you can all celebrate together."

"Two weeks!" exclaimed Mary.

"If you come down tomorrow sometime," Grant said, "you'll see how the walls are going to look. I'm going at them in the morning. I'm so excited!"

The next day, in late morning, we found Grant in the new

40

shop in his working overalls, with a wide-mouthed bucket of mixed paint. He was crushing newspaper up tightly, dipping it in the paint, and dabbing it with a certain regularity on the walls. The result was amazing. Two young men—from where, I never did know—had strolled into the house and were looking on.

Grant paused to light a cigarette and was surveying what he had done, with his head tipped ever so slightly to one side. He turned to the boys, "Like it?"

"Sure do, Mr. Wood. Is it hard to do?"

"As a matter of fact, it's very easy."

"Gee! Sure looks like fun. Could we do it?"

With other things on our minds, Mary and I left and went upstairs to look around. When we returned, Grant was still smoking and looking at the wall, but the boys were working like everything, having great fun, doing the stippling! Grant, as Fan always said, was a genius at getting other people to do things—or to persuade them that what he suggested was exactly what they had thought of themselves. "Anything he started," said Fan, "seemed to induce an itch somewhere along the line, where eagerness to work didn't exist, originally." At any rate, the painting was done, and the success of it relieved our minds considerably— it had made all the difference.

"I knew you'd like it," Grant said as he was collecting his stuff, getting ready to go home. "The boys were a great help."

One other incident in the moving and getting settled produced a few light moments. Grant had assumed, rightly, that Mary's furniture would furnish the shop, and that only Mary and her dresser and chair, clothes rack, and bed need go into the little room that had been the mortuary's family room. When all that was in there, it was just possible to slide the door shut. The other residents of Studio House, on the chapel side, would often call to her:

"Mary, are you there? Are you okay? Mary, let's hear you take a deep breath."

"Mary, are we going to have lunch in *there*, or will you come out?"

"Mary, can you get out? Do you want help?"

"Mary, are you *alone*? Shall we take charge of the shop until you wiggle out?"

When a mouse died somewhere in the underpinning of the

sliding door, it was impossible to get it out. If a shopper sniffed and asked in the presence of any house occupant, "What's that?" the answer was fast: "Oh, that's just Mary, she'll dry off sweet eventually."

Mary, getting sympathy for the rough treatment given her by her "house fellows," would only say, "Well, it would be much worse, wouldn't it, if they ignored me?" Grant, having all such things related to him, plus Mary's outraged complaints, would just sway back and forth, grin, and say, "Oh, I knew they would approve of you, Mary. I'm so pleased with the whole place."

The little room off the front hall, right at the foot of the stairs, was rented by Donald Horan, a teacher of the bass viol who had studied piano and bass strings at the Busch Conservatory of Music in Chicago and with Frederick Schauwacher, a young but well-known pianist who was also from Cedar Rapids. As well as teaching, Don had played with the Cedar Rapids Symphony Orchestra.

The extra room on the second floor was occupied by Jean Herrick, formerly of the Des Moines *Register*. Educated in journalism at the University of Iowa and George Washington University, he had already served on newspapers in Ames, Iowa, and Great Falls, Montana. Jean had fallen in congenially with the artists and was a good choice to help fill out the upper house.

The other occupants of Studio House were not without distinction. The top floor, with its vaulted peak, roominess, and "nice, warm bath," was occupied by the Edgar Brittens. The former white-tiled embalming room at the back and the head of the stairs became a studio for this artist who had had a rapid rise in local art circles. An exhibit at the Public Library gallery of the Art Association the year before brought Edgar to the attention of the community as "the artist who painted a mood in every picture." While studying dentistry at the University of Iowa three years before, Edgar found his artistic talent and gave up dentistry for the palette. Landscapes and figures were his special interests and many of these were worthy enough to hang in local exhibits and homes. A little later, he became Grant's assistant on some important mural painting.

The long hall into the Brittens' big open room had bare walls which were soon to tempt Ben Knotts, who did not live in the building, to do modern and very colorful murals there. Ben had

42

designed stage costumes and settings in Chicago, had studied some at the art institute there, was apprenticed to the Chicago Opera Company, and was associated late with the Hedgerow Theater of Philadelphia and the Little Theater at Hull House in Chicago. His watercolors had been shown in International Watercolor Shows at the Art Institute and the Philadelphia Art Alliance. Recently, he had completed murals for a Sioux City dancing studio. When Ben got on with what became known as his "Jungle Murals," traffic into the house increased because so many people wanted to see them.

In the big long room on the second floor Leon Zeman had his art school; a little cubby under the stairs was his sleeping space. Already, Leon had a splendid background. He received his education at the Art Institute of Chicago and under a group of private instructors which included Edna Robeson, miniatures painter of New York, John W. Norton of Chicago, and Pedro L. Lemos, the noted California teacher of design. Like Grant, Leon had also taught art in the Cedar Rapids schools and for the Tri-City Art League in Davenport, Iowa, as well. He also spent three years in commercial art work. With his wide cheek bones, broad forehead, tousled black hair, and his very white, slightly crooked teeth, Leon could look like a brigand.

Studio House was not a Bohemian outfit. The artists were serious young people who wanted a "home"—a place to work, teach, and study together. They were all capable of earning their living from their talents if given an opportunity. They were serious about Studio House and hoped with Grant that it would work out. Grant was terribly pleased and kept a fatherly eye on the colony. He dropped in two or three times a week—and never left without calling at our shop for a cup of coffee and a visit. Marvin, too, provided guidance to the artists here.

If a mortuary in a house had been news years before, a gift and china shop in a mortuary full of artists was news now, and the opening of Studio House was headlined in the *Gazette*. The paper's article hailed it as "the most unique art colony in Iowa." They reviewed the talents of all the occupants, included a note about Hobby House, which they referred to as an "exclusive gift shop," and went on to characterize the Studio House in the following way: "the members of the Studio House group are cemented in a common desire to establish an outstanding art

43

center for Cedar Rapids. The movement has the complete support of the Art Association and the cooperation of Grant Wood."

We planned a gay opening for our shop. The public was invited. We had a very pretty tea table, and our personal friends came to help and sup with us afterwards. Grant and the Cones and the "occupants" were invited guests. The long chapel room of yore in no way resembled its previous use, but looked like a home in gala mood.

There we were, all dressed up and waiting—the candles were lighted. I looked out the curved windows and saw Walter Reitz, chief engineer at Penick and Ford Corn Syrup and Products Manufacturers, where, until this event, I had been an employee, coming up the street. I thought it very decent of Walter to take time off to help us celebrate. He came up the sidewalk, turned, and walked up the steps to the porch. Removing his hat, he stepped into the door. His eyes opened wide at the candles and the pretty girls, but in a most solemn voice asked, "Will you please direct me to the funeral of Mr. McClaughry?"

The artists loved looking over our merchandise. They were very frank about everything, aiming to tease us, and Grant, in his way, was inclined to look at an assortment of colored glass, for instance, and remark, "This yellow is a lovely shade, almost light amber." But when he made no remark about the other colors, we knew what he thought.

Over the fireplace in the living room was the recessed alcove with the colored-glass window at the back. This used to be the spot—like a shadow box—for displaying some outstanding piece like a porcelain or a figure. If the boys had done a very poor painting, or found something delightfully ugly—to their sense of humor—they would come bursting in with a "suggestion for the window." We came to think nothing of finding the spot occupied by some outrageous drawing, or some piece of *anything,* often with a little card—"Compliments of the Artist. Price $900. Very rare."

Someone mentioned this practice to the press, and a reporter rushed in one day to stand before the fireplace and contemplate the alcove. Cowan pottery, ivory outside and turquoise inside (among other colors), was very popular then, and a low bowl with a slender, sprightly figure was displayed in the window. The reporter looked at it.

44

"Is that what you *usually* have up there?" he asked.

"Oh, yes," said Mary, "we have a number of bowls and figures and fine crystal that show off splendidly in the alcove. We have a rather *unusual* assortment to use."

"Well, I'll be darned," he said, and went out about as fast as he had come in.

The boys in Studio House often helped us with our unpacking. There was no outside entrance to our basement; so shipments arrived at the front door and were carried down the inside stairs to the basement. Now and then when a carton of fragile things arrived, we had to open it in the front hall. We tried to do this at night, or very early in the morning, but sometimes we could not escape having to unpack immediately. Of course, everything coming out of the boxes had to be checked with invoices and priced, and great confusion resulted when customers helped, with or without permission, with the unpacking. Many quick sales were made, however, when they were the first to see something. The Studio House residents were especially interested in what came out of those boxes. If they found something that pleased them, it was apt to be found later in the alcove, replacing whatever had been there. At first, we *lost* items on the invoice, but we got in the habit of checking the alcove. "Life is real, Life is earnest, Life is just one unpacking dream," Leon used to sing.

Sometimes Grant would come in and ask to borrow a vase—pottery or copper, usually—and we would know that Dave had an out-of-town funeral and more flowers than he could accommodate on the trip to the more distant cemetery. When that happened, Dave always called Grant, and there would be an all-night session at 5 Turner Alley, painting fresh flowers that were always hard to come by, especially in the winter. Grant would always return the piece to us the next day. Now and then, in an exhibit, a flower painting by any one of the house's artists might have in it a "familiar" from our shop.

On his regular visits to Studio House, Grant, who was busy painting in his own studio, would stop in for that cup of coffee and visit with us, and he'd beam happily. It was all working out—the classes were enjoying it, and the inhabitants of the house were congenial and got along well together.

"Oh yeah!" Mary would say, raising her eyebrows. But there seemed to be an acceptance all around, judging from the affection-

45

ate technique of loaded insults. There were moments, remembering what Grant had said, when we wondered *who* was *The Good Influence*. Who was having more fun with the shop than the painters, and who was having more fun than two old maids and a parcel of painting-men?

Often, customers would be visiting with each other, or with us, quietly doing their shopping, when an awful sound would be heard—startling, unexplainable, unearthly, alarming—a sound that a yard full of hens were incapable of making. "Think nothing of it," we would say. "It's just a new student of the bass viol in Don Horan's studio next door." Once when we were a little frantic with a shop full of customers and four more rummaging around in the bottom straw layer of a carton we were trying to unpack in the hall, Leon surveyed the situation and said, "I'll just put my head in Don's studio. Three bad sweeps of his bow on the strings will clear the house!"

The one complaint about Studio House came from Leon. If Grant were in the shop and Leon spotted him, he would come in to say—it was a regular thing—that he certainly thought there should be a life class with models. Grant would agree, but he did not think nude models were appropriate, everything considered.

"But what is an art school without life classes?" Leon protested. "They are a regular thing everywhere, aren't they?"

"Well, yes, I know, Leon. But look, I have an idea. Let's go upstairs and talk about it."

We heard no more complaints from Leon. It was late fall, and we were open evenings before the holidays. In the middle of one evening, we heard sirens whine up the avenue and assumed they were off to a fire call, but instead they came to a stop in front of the house. Doors opened, heavy feet pounded up the stairs, and there was a commotion up on the second floor. Two police officers poked their heads into our door, pulled out, and went on their way. There was a small crowd in the street by now, but the officers got into their cars and drove away. When the place had emptied of extra people, and the shuffling upstairs had quieted down, we turned to see Leon in our doorway.

"False alarm," he said. "But Grant was right."

"About what, for mercy's sake?"

"About nude models. If he hadn't gone to the trouble to get a flesh-colored bathing suit, closely woven, we'd have been in the

46

soup tonight, all right!" He rubbed a smudgy finger on his nose. "Someone phoned the cops that there were nude girls up here in this art place. I think they were disappointed when they got here to find it wasn't quite true. But from a distance, well, they serve the purpose. Grant was right, as usual. Got any coffee?"

For all his nonchalance, he pulled out a very large white handkerchief and mopped his brow. "Gee, that coffee was hot!" And he went back up to his "nude" model and students.

Also that fall, the Cedar Rapids *Republican* ran, in a special "Seville Edition," a tongue-in-cheek account of one of the many "ribald" shows put on by the artists and members of the Art Association. The story was probably made possible through the exigencies of Jean Herrick. According to the account:

> Grant Wood, well-known artist of Turner Alley, was in jail here tonight pending a thorough investigation of the disappearance of Senorita Pepita Gallegos, Spanish model. In adjoining cells were Edgar Britten, Ben Knotts, and Leo Zeman, who were believed by police to have information regarding the missing girl.
>
> Alarmed when the missing girl failed to return to the Marvin Cone home, where she has been a guest, her host notified police and told them he understood she was to attend a party either at Wood's studio or at the Studio House.
>
> Upon investigation, police found Wood's studio in a state of wild disorder, while the artist stood before a half-finished picture on his easel and rocked back and forth on his heels, all the time mumbling incoherently about "Who's got a cigarette." A high, tortoise-shell comb lay on the floor and a piece of black fringe, believed to have been torn from the Senorita's mantilla, was found caught in the door.
>
> The artist, apparently in a daze, resisted arrest and six patrolmen were called to load him into the patrol wagon. After a thorough check of all radio stations it was determined that all operators were accounted for and the investigation turned toward Studio House.
>
> Here the police trapped Knotts, Britten, and Zeman in the midst of a tea party surrounded by young women. Zeman was the first to see the officers approaching and attempted to leap out a third story window but was seized by one of the officers before he could escape. He is alleged to have murdered a dancing girl in Paris a year ago while masquerading as an Apache and will doubtless be brought to trial on this charge.
>
> Britten and Knotts both admitted having attended a party earlier in the evening at Wood's studio at which Senorita Gallegos was a guest, but refused to answer further questions upon advice of their attorney.
>
> When arraigned before the desk sergeant, Wood was confronted

with a bundle of letters (large bundle) which police alleged to have been seized in his room, written by Senorita Gallegos from her home in Seville, Spain. He denied that he was engaged to her, however, and one of his friends suggested that Grant may have written them himself and had mailed them abroad. Both Britten and Knotts have been seen frequently with Senorita Gallegos since her arrival here and police are inclined to believe they are withholding information. The artists were all held without bail.

This show, *A Night in Seville,* and other shows—*A Night in Paris, Mexican Party,* and *An Italian Affair*—were forerunners of theater Grant put on later, up in the studio. In fact, they were the early forerunners of the Community Theater itself.

About this time, the Garlic Club came into being. Grant and a group of friends, that included Leon Zeman, Ralph Leo, Jim Farquhar and Tex Grantham of the *Republican,* Betty Low, *Gazette* writer Gladys Arne, Helen McClaughry, George Keeler, Emmet Moynihan, and Keith Vawter, who headed the Redpath Vawter Chatauqua System, met regularly for lunch at the Travel Inn. The inn, just three blocks from Studio House, was run by the A. C. Ehmans, ex-actors. The mutual enjoyment of the members of the club, which took its name from Grant's practice of rubbing a salad bowl with garlic before mixing the greens, a practice he had picked up in Europe, became widely known. No one barged into the sacred circle, including the Ehmans, although many wished they could, just to listen to the talk, especially Grant's stories and experiences.

John Reid, Henry Ely, Arnold Pyle, David Turner, and Marvin Cone also often joined the more regular members around the Travel Inn's red-checkered tables. Everyone would have enjoyed seeing more of Marvin in these days, but he was not as free as many of the members, what with his teaching, painting, and his family, which now included a young daughter, and besides he did not work downtown where he could conveniently spend an hour for lunch with them. Some of the group, especially Grant, made up for it by being a frequent visitor in Marvin's home.

Studio House, so satisfactory in so many ways, was not able to weather the Depression days. The *Republican* combined with

48

the *Gazette,* and Jean Herrick was out of a job. He got another job in Des Moines, married pretty dancer Bonnie Fisher, and moved away. Leon had marriage in mind and thought it best to go back to a regular job with regular pay. Don Horan decided that his ability as an accountant was worth exploring as a steady job, with the bass fiddle on the side and for symphony work. Edgar Britten had the opportunity to have a good job with a museum, for which he was well suited. He and Frances were separating; so almost overnight, they were gone.

Mary and I, the incidental occupants of the lower floor, found ourselves alone with nothing above us but emptiness, echoes, and memories. We were without the daily word with one artist or another, and with fewer visits from Grant, who was now busily occupied in the "decorating business," working with Bruce Mc-Kay on his houses. We were not completely deprived of his cheering and educational company, however, and, of course, he went to the Gift Show in Chicago with us.

The only happiness in the situation at Studio House was that Mary moved out of her "squeeze box" to the amazing vast-ness of the top studio room. She remarked that she felt, in the early days in her new abode, as if she would "float up and around the house." Her former downstairs room was shelved part way up. One day, Grant came in the shop in a hurry, went to the little room, and came out to announce that he had enough silver China tea paper left over from a job he was doing, to cover the upper part of the room. He came back later, put it on himself, took a cup of coffee from Mary, lighted a cigarette, and stood there, surveying the result with utter satisfaction.

With Hobby House still going well, the busy mind of Dave Turner came up with the idea that the empty second floor would make a wonderful tearoom. He not only outlined all the ad-vantages to us, but said that he would finance necessary altera-tions. Mary and I were reluctant. We were weathering the De-pression, business was satisfactory, and you might say, we were catching our breath after the exciting interlude of Studio House—much as we continued to miss our friends. But Dave, the born promoter, saw the venture as an asset, thought "these girls" just the ones to give the city a new exclusive eating place.

The tearoom was fun while it lasted, which was almost ex-actly two years. The interesting event connected with the tearoom

was our idea. We suggested that if Grant had any paintings leaning up against the walls of the studio, he might hang them on our walls, where they could be seen and sold. The old Dave-argument held. We needed our walls decorated; he had pictures sitting around. For two years, Grant Woods covered our tearoom walls, and one sold every now and then. They collected comments from appreciation to candid fault with the way Grant painted trees—with the way Grant painted everything. No one minded though. As Grant said, any comment meant that someone had looked at the painting long enough to have a reaction, and reactions themselves were good.

When the tearoom closed, when our delightful cook and second cook—Cotton and Little Ruthie—and the college boy hashers had gone, and when the tradesmen no longer came up the stairs outside the building on the Seventh Street side, and Grant no longer came over to eat with us out on the garage roof under the elms, we settled down to paying off our bills and giving full attention to our business.

Grant said, as the pictures came down and he was putting them in the truck to take them back to the studio, "I wish you girls would pick out a picture for each of you. Will you come up to the studio and see what's there and do that for me?" Knowing that Grant needed to sell those paintings, we said no. He reminded us of how we toted him and "things" around while he was doing some decorating jobs in town, and it would make him feel better if we could each find a picture that we would care to have. *Care to have!* We promised that we would find such a one, each of us, with no trouble at all, so he went away happy.

When Grant said, "I want to repay you," Mary, surprisingly, said, "To hell with repay." And that vehemence from Mary indicated how much we felt that Grant owed us nothing, but that we owed him a great deal. Knowing him was quite an education in more ways than one. Neither of us ever did own an original Grant Wood—the auspicious moment to go up and pick out for ourselves two Grant Wood paintings never came.

We missed Studio House, of course. Now, however, Mary could take a deep breath up on the top floor, removed from shop problems. And there was the whole empty floor. We did put it

to good use once, when Mary and I gave a party there celebrating the coming marriage of John Reid's daughter, Catherine or "Catsy," to James Cooper. The most interesting event of the party was the arrival of Grant Wood—dressed as a *fish!* He had made the costume, scales and all, and he could hardly walk with the tail. I do not remember a single other thing about that party except that, as it was about to end, John Reid, Bruce McKay, The Fish, and very possibly Dave Turner, were flat on the floor, shooting craps.

If one lived within the "circle" of Grant Wood, one had a special kind of exciting and "howling" life.

Community Theater

Grant put on several productions in 5 Turner Alley. He said he could seat seventy-five people there—fifty would have been an amazing number. But he hung curtains from the slopes of the west alcove, the alcove his backstage, and put on one-act plays; there was usually some sort of refreshment to follow.

When Catherine Hunt, daughter of Dave Turner's neighbor and friend, came home from dramatic school, she brought with her the idea that a theater group should be organized in Cedar Rapids. Her father sent her to Dave, who, of course, turned the idea over to Grant.

Grant had in mind a list of people who should discuss this matter, and Mary and I were both on it. When he came to us, he mentioned the need for a place to meet. Mary and I knew the answer right away, but we wanted to "enjoy" his approach—which was terribly troubled.

"It occurred to me," said Grant, blandly, of course, "that since no one is using the upstairs, you might let us meet up there. It would be handy for you, too."

"It's bare as a bone, Grant. What do we sit on?"

"Well, something can be worked out. Each person can bring a folding chair. There will be about thirty of us altogether."

"And it would be nice, since no one is using the kitchen, that we arrange for coffee and cookies afterwards."

"That's a wonderful idea!" said Grant (who had it already in his mind to suggest it, and to pay for it).

"Hazel and I will be the first to treat the future thespians. But don't forget the *seats!*"

The idea took shape fast. I do not recall particularly about the seats, but I do remember that only two people were sitting on the floor at the meeting. Turners, Reids, Wood, Cones, Fennels, Coopers, and Shaffers were all there—it might easily have

been a meeting of the Art Association. No buildup was necessary. A permanent board was selected and rotating terms were established. No one refused a job; everyone was excited, and Grant and Marvin, as expected, were pleased.

Catherine Hunt was the catalyst who would take charge and direct. *Dover Road* was chosen as the first play. Marie Fennell and Tom Sinclair were to be the leads, and Grant and Marvin took charge of the scenery—once again! The Killian Company consented to let us use their third-floor tearoom for dress rehearsal and performances, but we still needed a place for general rehearsals and to work on scenery.

Then, all eyes turned on us. Obviously, that big empty second floor above Hobby House was a natural—and we had access to it in the daytime. And that is how it turned out, for a long time. Customers who had jumped when Don's pupils used to pull sour strings on the bass viol were now startled by the sound coming from second-floor rehearsers. I remember when Catsy Cooper and John Carey had the leads in a cast and Catsy's part required her to call to John agonizingly. During rehearsal, a quiet shopper jumped when Catsy shrieked, "Henry . . . Henry . . . Heeennnry!" And often when voices raised in a lively row floated downstairs, eyebrows were raised at us. Once, a Halloween trickster stuck a piece of paper on the front of the house with big crayoned letters—HAUNTED.

Catherine Hunt worked very hard, but her training was more on technical signals than any experience in handling an untrained company; so Mary and I took over the directing for awhile. But Mary and I had a business to run, and we had to attend the centralized exhibitions of our trade. Grace Glass, a *Gazette* writer, then took over the direction of *The Queen's Husband,* in which, to the delight of the local audience, the young realtor in town, playing the king, found his crown toppling and caught it just as his script line was: "Well, I caught that just in time."

For that same show I was to delight in watching Grant and Marvin painting scenery again, and joking and laughing just as they did as high-school boys. But there was more to it this time. They were actually "making" very elegant walnut shelves and leather-bound books to fill them. Grant and Marvin invented titles for the books as they went along. Grant would do one, and

53

then Marvin would do him one better, and so on. Every title was actually a gross insult to some prominent Cedar Rapids citizen: *You Can Live With One Ear,* by Dr. Wayne Foster, and *Brother Can You Spare a Dime,* by Van Vechten Shaffer.

None of us now can remember all the others. We meant to copy down those titles, but we never did. The rehearsing group was hilarious as they read them and we had to turn people away from rehearsals who wanted to come up and see the rumored set. After the first performance, the audience floated up to the stage in a body to read the book titles. It caused a riot. Too bad the scenery had to be washed off; too bad the titles were not recorded; too bad none of us can remember what we thought we would never, never forget.

What Price Glory and *Outward Bound* were produced in the Congregational Church, which had given us the use of their basement stage for a period. Billie Stamats played the lead in *Cinderella;* she was our first and only truly professional actress.

When the committees were stumped, they always turned to Grant. Once for a special sound effect, he hung a sheet of tin, which, when shaken from one end, produced better than the Lord's thunder. For a scene on shipboard during the rough seas, Grant devised a backdrop on a roller. If the stage could not ride like a ship, the backdrop could roll like the ocean, and the effect was the same—the audience got seasick! One script, I remember, called for an old-fashioned organ, and Grant painted the organ on the backdrop. After the performance the audience came on stage to be sure it was only painted on. That, too, had to be washed off.

Through the persuasion of Fan Prescott, who played leading parts in several of these early productions, and with her guarantee of good order and behavior, the Community Theater was allowed to use the auditorium at McKinley. It was a roomy auditorium (more income), and it had a splendid stage.

Mary was in charge of the box office for these early productions. One day, a shop customer called to say that she had failed to receive the package she was expecting. "But I got four seats in the fourth row for Thursday night," she said.

To the chores of running a business, helping with plays, and serving as box office was also added the responsibility of advertising for people to try out. In one case, we caught quite a fish.

54

We were to do the musical, *Broadway*. The idea was appealing, of course, and we had a good turnout of hopefuls. The show was quickly cast, except for the small part of the detective and the lead, a singing and dancing part.

One morning, a young man came up the steps very quietly and paused just inside the French doors of the shop. Not far from six feet tall, he had a round cheerful face and a long, lanky body. He was obviously very shy, and a little scared.

"Is this the place to come to about the parts in the play that are still open?"

"It is. The lead, and the part of the detective, a small part. Which part interests you?"

"The detective, I think."

"Ever been in a play?"

"Not exactly. No, not like this."

We were taking this young man in—inch by inch. The right age, attractive. And we were desperate for that lead.

We asked him, "Do you sing?"

"No. Well, yes, I sing in our church choir."

"Live in town?"

"Yes."

"Can you dance?"

"Well, yes, but I've never danced much, really."

"How would you like to try out for the lead, the young man who sings and dances in the show. You're the right age and build."

"Do you think I could do it?"

"Do you think you'd like to try?"

"Well, I sure would like to try. Will there be someone to help me?"

"Yes. And it is understood that you may start and not pan out for it, and we may have to let you go. You would understand that, then?"

"Yes, I would."

He had a rather nice voice. The songs were no trouble. The acting took coaching, but he was intelligent, good-natured, and a hard worker. I can still see Billie Stamats, her long skirts held up with both hands, teaching that young man step-by-step the routine of the show. He never quit. He was always on time, always willing to work late. He may have been a green hoofer, but his performance brought great applause. That young man was

55

Don DeFore, now a well-known film and television performer.

Another local performer in the early theater was Bruce McKay, the architect-builder who remembers those theater days:

I was in the play *Journey's End* and played the part of Osborne. The following year there was trouble casting another play . . . and in refusing to take a part I explained that happy as I was to be in *Journey's End,* I was not an actor and I thought it poor taste for a married man with two young, growing boys to make public love to some local girl. A few days later Grant appeared in my office and urged me to accept the part, that he had read the play and thought it just suited my talents. Even so, I refused, and Grant left with regret.

The night of the play Grant sat directly behind me. The leading lady turned out to be a professional, a voluptuous guest star, and the leading man, one of our leading amateurs (later a professional). The play started simply enough but as it went on it got warmer and warmer and when finally our handsome amateur enfolded the voluptuous guest star into his bosom and was breathing love words between gasps, I heard a chuckle just behind me. I turned, and there was Grant's face, beaming, eyes twinkling, thoroughly enjoying himself. He said afterwards that if only he could have had me commit myself to the part, it would have been one of his high achievements.

56

The Decorating Period

Our delightful Irish helper, Mrs. Ellison, who had helped us polish the hardwood floors and the dull woodwork when we moved to Mansfield House, had worked for my family and for Mary before she came to help us with the shop. One day, looking at her rosy cheeks, my stepfather dubbed her "Posey," and she was Posey thereafter to all of us. Grant was entranced by her, and asked her if he too could call her "Posey," and she, properly awed, said she did not mind. One day, Grant asked Mary if he could borrow Posey.

"I guess you can, Grant," Mary responded. "But she has more cleaning jobs now than she can handle. And remember, she has two girls at home to care for."

"It wasn't exactly a cleaning job I had in mind," said Grant.

"Oh, all right," snapped Mary. "If you ask her to stand on her head for you, she'll do it!"

Later that day, Posey told us that "Mister Wood" had asked her to pose as a farm woman for the murals he had been commissioned to paint for the Montrose Hotel in Cedar Rapids. She wondered if we could spare her the time needed.

Of course, we hemmed and hawed, just to tease her, but we were delighted; Grant was delighted. We teased her about how hard we would have to work, but we let her have all the free time she needed. That would have been the moment to ask her to stand on her head, which Mary said, *we should have tried.*

While Posey was out of the shop, we managed. One morning after the posing job was over, she was in when we arrived, and the moment she saw us, she burst into tears.

"Posey! What on earth is the matter?"

"Oh, nothing! It's—it's just what that man did to me."

"That man?"

"Mr. Wood. It's what he did to me."

57

Mary and I looked at each other in horror. "Posey, look up, dear, and tell us what did Mr. Wood do to you?"

"He—he *wanted to pay me for posing.*"

After we got back to normal—after that scare—we explained to her that artists always paid hired models, and we knew that he was going to pay her. And what is more, he had offered to pay us for the time she had missed in the shop.

"Oh, you wouldn't!"

"Of course not. But you must accept your rightful pay, for if you don't, he will be embarrassed. Don't you see?"

Grant paid Posey, and he said she thanked him very nicely and he was grateful to us all. After that, any time Grant appeared in the shop when Posey was there, we expected to see her salaam. At any rate the farm woman with the pink cheeks in the Montrose murals, now on exhibit at Coe College, is our Posey.

Once during Studio House days, several of the artists were in the shop with Grant when he mentioned he had had a visit with my mother and that he thought she would be a good Yankee to paint. I was very indignant. "Isn't it enough that you take Mary, and Posey, and now my mother—I'd just like to know when I get picked for work."

Leon suggested I might contact Marvin, as he was on a run of clowns, and someone else chimed in that maybe Ed Bruns needed things for his farmyards. Grant put a stop to it all. "Hazel," he said, "the next time I do a still life of autumn flowers and apples, I shall tuck you in as a little brown nut."

Grant's commission from the Eppley Hotel System for the Montrose Hotel murals was his first major decorating job. Edgar Britten helped him. The murals were done for the Corn Room, and Grant's work pleased the hotel people very much. As you sat at a table eating, you were sure you were in the middle of a cornfield; you almost felt the crunchy cornstalks under your feet. The men who used the room for meetings loved to tip their chairs back against the wall and make big business of picking off an ear of corn. The chandelier even had corn-colored bulbs glowing from the tops of upright ears of corn, with pendants of graceful corn leaves, and was made especially for the room.

The Montrose job bought Grant and Edgar work on the Eppley Chieftain Hotel in Council Bluffs, Iowa. Grant wrote to Dave: "The Corn Room here is nearly completed and we start

58

on the Pioneer Room immediately to get finished for the Grand Opening February 22nd. Mr. Eppley is pleased with the work."

As Grant became increasingly more famous, notices at the hotels' desks urged people not to miss seeing the Corn Rooms and the Wood Murals. In 1970, the Chieftain was torn down, but before it was demolished a California surgeon removed with a scalpel the murals that Grant Wood and Edgar Britten had painted.

Arnold Pyle, who, at the time of this writing, was painting again after a long service in the offices of an electronics industry in Cedar Rapids, visited with me about Grant. Arnold, a self-taught artist who once enrolled at the Chicago Art Institute for two days to do a lithograph, was assistant to the director of the Little Gallery for five years and also taught art there. He was a member of the Board of Directors of the Art Association for several years and a director and faculty member of the Stone City Art Colony. In the thirties, Arnold was a member of a progressive art group known as the Cooperative Artists of Iowa.

Pyle's paintings took form in the railroad yards, where an engineer friend would jockey engines and cars to better the lighting and arrangement. Elevators in the small towns close to the city were also a favorite Pyle subject, and Arnold painted on the spot in all kinds of weather. *Big Hook,* a sweepstakes winner, was painted in Solon at the scene of a train wreck. Later, he rented a studio in the Granby Building.

The style of Pyle's paintings in the thirties was ruggedly individualistic—a style that distorted form and exaggerated color to bring out salient points in a technique that developed by leaps and bounds to set him forth as one of Cedar Rapids' young artistic leaders.

In a preface for a catalog of paintings to be exhibited by Pyle in 1935, Grant Wood wrote:

Arnold Pyle's work is distinguished by the courage of color. No symphonies in soft and easy greys; his paintings successfully attempt the much more difficult feat of controlling and harmonizing full intensities.

He is his own man in both color and treatment of subject and does not lean upon the mannerisms of other painters for his personal-

59

ity. He has a quality of blunt honesty which serves him well in his work and keeps him from being compromised by prettiness or affectation. His versatility is exemplified by the skill with which he handles oil, water color, or the lithograph crayon.

Like numerous other Iowa artists, he received his first recognition at the annual Iowa State Fair exhibits where he was awarded several prizes. He has had one-man shows at Council Bluffs, at the Joslyn Memorial in Omaha, and at Increase Robinson's Gallery in Chicago. He was represented last year by work in the Kansas City Midwestern exhibition. The International Water Color show at the Chicago Art Institute has included paintings by him for two years. His work was selected for the Philadelphia Annual Exhibition last year.

Of his painting, *Train Moving* which was shown in that Philadelphia exhibit, Thomas Benton exclaimed: "Hell, did he paint that? That was the only thing in the show!" An equal tribute lies in the fact that Alexander Brook bought the picture. Both Brook and Benton were on the jury for the show.

No one can made a chronological survey of Arnold Pyle's work without being thrilled by the strides he has been making in perfecting his technique. But to expatiate on his potentialities would do him an injustice; accomplishment is already his.

Arnold was not only an exhibitor, but judged exhibits at fairs and art shows around Iowa. In 1936, he took a job and, after five years, had little time to paint. After retirement in 1968, he turned again to painting. His style has mellowed, but is still his own. His painting of the late sixties is done in acrylic in a new form for him—abstracts.

When we talked about Grant, Arnold recalled:

If Grant just wanted to paint a house, he'd paint a house and do a good job. Do you remember the old Whelihan Drug Store when it was moved to the corner across from the Montrose? It seemed they needed some interior decorating service. Grant told them to paint the wall the color of a chocolate malted milk. How's that for being basic?

Arnold continued:

When Charlie Gertsen was doing over the beer joint in the Montrose, into the Hurdle and Halter, Grant suggested redcheckered tablecloths and a zither player. There was at that time one, just one, zitherist in captivity, down at Waubeek. Gertsen didn't buy the zither-player idea, but the suggestion was typical of Grant, the man who could use

60

screen-door moulding as a decoration in a picture frame. And in the early days he often used it.

He did a mural for Henry Ely, who had erected a pretty cottage on a downtown corner for his real estate office. Grant's mural was a great, lighted outdoor sign perched on top of the tidy little house, advertising Cedar Rapids as the "City of Homes."

Arnold also underscored what we knew, that Grant Wood was a painter, designer, carpenter, architect, silversmith, cement and stone worker, crayonist, and sketcher. He had many incidental crafts at his fingertips; he tried things to "see how they went."

Arnold was, of course, the subject in the painting, *Arnold Comes of Age,* and Arnold served on the staff of the Little Gallery and worked with the Art Association, and is the only surviving contemporary here who reaches back to those days of Grant and painting.

Ed Bruns, who was the man with the longest uninterrupted record of painting and teaching in Cedar Rapids, and who had served on the board of the Art Association, died during this writing. Before his death, we visited about old times. He was a fine man, with a fine family, and an outstanding figure in the public school system. I regret I have no record of the hundreds of paintings he sold in the community.

Grant's decorating work also extended into the homes of the community, and he often selected lamps, pictures, and accessories from our shop. In early afternoon, he would come to the shop and explain in careful detail what he needed for a certain home, and would wander around the shop pointing out things he liked for a certain place. At this time he had several decorating jobs going at once and was much distraught in the keeping going.

"Would it inconvenience you girls if I took a number of these things out to see how they would go?" he asked.

"Take anything you want, Grant."

"Thank you. I appreciate it."

Then there would be a slight pause.

"Is your client going to pick them up?"

"Well, no. I wondered . . ."

"Do you want us to take them out?"

"Do you think it would be inconvenient for you?"

"Perfectly convenient if it can be done a little later in the afternoon."

"That will be fine."

So we would check his list, and he would leave. Sometimes, he paused at the door and turned to ask reluctantly, "Would it be a lot of trouble if you picked me up on your way out? If it's going to be out of your way . . ."

As we who were Grant's friends and contemporaries talk about him now we cannot remember ever being unwilling to do what we could to help him. Nor was he ever unwilling to do anything he could to help us.

Grant had an equally indirect and effective way with his clients. I remember the time Grant admired a very fine print, by a famous artist, well framed, which we had plunged a bit to buy for the shop. "That print," said Grant, standing before it, "would be perfect in this home I'm doing—in the living room, on the wide wall. But I have a problem. How to get it there."

"We'll take it out for you, you know."

"It isn't that kind of a problem. She already has a picture on that wall, and it's pretty bad."

"Can't you take it down?"

"She just bought it, in a department store downtown. It was delivered yesterday, and she's crazy about it."

"*You* can tell her, can't you?"

"Not without telling her what I think of it, and that would be insulting and would hurt her feelings."

"Maybe you don't know it is there."

"She told me that she'd taken care of that wall and I needn't bother."

Nothing more was said about it until after coffee.

"I think I'll let you take it out, anyway. May I go along?"

That was the last we heard of it. The client paid the bill and we forgot to ask Grant what technique he had used. However, we learned it from the client herself when she boasted that she had chosen it herself after her friends missed it in the shop. She told them:

Grant brought this one from the girls' shop out for me to see. He liked it, and wanted us to enjoy it for a day or two, just to share his

62

pleasure. He suggested that I put the other picture away, maybe in the attic, but handy to bring back when he took the new one away. I really didn't like the new one a bit, but Grant wasn't able to come out for a week or two and then he had to go out of town, and it was a funny thing—we got used to that picture, and somehow we knew we were going to miss it. So when Grant came out to take it back and offered to bring the old one down from the attic, I decided this was much better after all. We just love it now. When I told Grant I was going to keep it, he said he wanted me to be happy and satisfied with that wall, and he was sure it was all right with the girls if I kept it— had they called for it?

Grant, and Marvin, too, had a firm belief that if you expose people of average intelligence to good art and good taste, they will react appropriately, and they are completely sold when they are convinced the discovery is entirely their own.

Grant played this gentle trick in many ways, many times. He never let a needed correction go unmade although it might take a "I really think in the long run you will like this finish better"— or this shade, or tint, or mixture—with no relenting on his part. But it was all so gentle, so considerate, that his clients told us many times that the nice thing about Grant was that he allowed them to make the decisions. Sometimes his clients complained that he shunned really outstanding effects, that he muted and toned down everything. But restfulness and harmony were on the increase in many of the city's fine and modest homes. Now, with Grant gone over a quarter of a century, they still boast of their lovely interiors.

During this decorating period, Grant went to a gift show with us. It was one of the big ones where exhibitors from all parts of the country and abroad set up for two weeks of trade showing at the Merchandise Mart in Chicago, and on at least three floors of the Palmer House. Many exhibitors were themselves artists or craftsmen, coming from foreign countries in native costume, a regular part of the scenery of the show.

Amazed, Grant wandered in and out of exhibit rooms quietly assessing the whole show. We equipped him with a show book and listed him as a Hobby House assistant; so he had free access anywhere he wanted to go. He introduced himself to the artists in the New York Graphic showroom (reproducers of famous paintings, they were, in time, to do some reproducing of Grant's work). And he became familiar with the showing of the Associated American Artists.

When Grant found something that appealed to him in the show, something he might use in his decorating work, he would lead us to it. "If you are buying here, and if it is convenient, I think I could dispose of this—or that—for you," and he pointed out things. Or he would ask, "Do you carry this line in the shop? I've never noticed. It is really lovely and the prices seem very reasonable for the quality." He never missed a thing. Nor did he ever demand that we order anything especially for him.

Grant had just this sort of consideration for his customers, too. Dr. McKeeby, a widower, was married again and bought a house in a new residential section of Cedar Rapids. Grant was asked to decorate the home. He and the pretty new wife went over the house and the McKeeby possessions.

"It's going to be hard to get rid of that chair, Grant," she said. "The Doctor just loves it and makes for it as soon as he gets home." They both contemplated the large, black, stuffed leather platform rocker, an "institution" in homes at that time.

"It just has to go, doesn't it, Grant?"

"You say he is very fond of it?"

"Oh, yes. We've already had arguments over it."

I can picture Grant, by now in his postural swaying. He was thinking. Then, I have no doubt, he looked at the disturbed woman and said, "I have an idea." Grant decided that if that black leather platform rocker were so important in the home life of the doctor, he would just plan the decoration of that room around the chair so it would not be an eyesore. He would try to fit it in quite naturally. And that is what he did.

In another instance, Billie Stamats wanted a picture of Grant's—the little pig picture—which we had on display in the shop. Grant told Billie that it was not really suitable, that it would not fit into the decor of the Stamats' home on Linden Drive. This was the way Grant was with his friends. Money from the sale of that picture meant daily bread and butter to him, but if he did not believe it was right—that was it. And he always expressed himself in a mild, bland tone, with little emphasis, but so much *power!* Later, when Herbert and Billie Stamats acquired their farmhouse on the Highway 30 cutoff to Marion, between Mount Vernon and Cedar Rapids, Mary, Grant, and I worked with Billie on the decoration. Then we took the little pig picture out to the new home, for Grant had decided that the farmhouse was the appropriate place for it.

64

Grant had painted the overmantel for the living room of the Stamats' Linden Drive home, and it was during this time that Grant and Herbert developed their fine friendship. Billie was away, and Herbert, alone and rather lost on evenings and weekends, got into the habit of stopping in at Grant's studio to watch him work on the piece—watch, visit, chin. Their friendship was another of those understanding and affectionate cushions against which Grant could lean and relax with utter confidence.

A good friend with whom Grant did a great deal of work was Bruce McKay, who served as a member of the board of the Art Association and was endowed with the sensitivity of an artist. He, Grant, and Marvin "talked the same language." The homes Bruce built won him acclaim outside the community. The Armstrong house was featured in *Art and Decoration*, and the John Miller home on Cottage Grove Avenue was given a double-page spread in *Architectural Forum* and was included in Simon and Schuster's *1940 Book of Small Homes*.

My own family home was designed, constructed, and decorated by Grant and Bruce, even to choosing the lot, and it appeared on the cover of *Building Materials*. Bruce had been asked by a manufacturer of shake shingles to use them in this community in order to let people see their appearance and value. He offered Bruce a special price, and Bruce passed on the saving to my family, and designed the house, "Northwest Chalet," with the high-pitched roof. The shingles were supposed to weather and darken while the trim of the house was kept painted white. I had wanted a home. My family said they could not afford it. Grant and Bruce said we could. So, as a sort of a challenge, between them they proved their point. It was, as they promised, a good investment.

Bruce told of building another home for a couple whom he advised to employ Grant Wood as decorator:

When we had Grant with us on a job there were no mistakes in color, or finishing, or furniture. However, this couple didn't like his "crazy paintings," especially *American Gothic*. The house was finished, and the woman bought a carpet for the living room that was a mid-lavender. The carpet was laid in all its horror and no one liked it, especially the woman. In tears, she asked what could be done.

I again advised Grant Wood. But Grant refused her. He told me he didn't want to correct other peoples' mistakes and then later be blamed for the final results.

65

After much urging on my part he finally agreed to try. By changing the color of the walls and purchasing drapes of the proper—just right—color, he turned the carpeting and the entire room into a thing of beauty. As I remember it, Grant spent two hours on the work and charged the couple six dollars.

In some casually written notes, Bruce recalled that Grant never bothered him or Kenneth (his brother) with his troubles, and that he was apt to arrive at Bruce's home anytime accompanied by Chuck Clark, Arnold Pyle, or the late George Keeler, and George would have a gallon of homemade wine. After about an hour, George, Chuck, and Grant would literally be boiling in oil about many architects and artists and writers, with praise for Frank Lloyd Wright, Ruth Suckow, and Jay Sigmund.

Bruce also jotted down:

He advised me to write my experiences with people, the things I told *him*, but I told him that would be betraying a trust. He thought them worthy. He was working on plans for Community Theater, sketches. And on *Iowa Barn* . . .

He said to me, "Painting or drawing is not dependent on the hand's ability or dexterity. If I were to lose my right arm, I think I could go on as well with my left. It might take a year or two, but I *could*. I have what I've got *in my head*." Another time, "To be a good artist is not a gift. A man isn't a genius because he produces good painting. Art is like being a plumber or a carpenter. If a person works hard enough, he will succeed."

On all our construction jobs there was always the finest feeling between Grant and all of the mechanics. He had the greatest respect for all men who could do things with their hands. To achieve his desires, unorthodox methods were at times necessary, but Grant's humble attitude always received cooperation needed to achieve.

One of the foremen posed as the farmer in the murals for the Montrose Group. The fellow didn't care about art, but he did it to please Grant. . . . He gave me a painting of the park where we used to picnic, overlooking a portion of the city—in greens. It hangs above my desk. . . . He made a book jacket for a then unknown author, for a publishing company, the original on brown paper. The author greatly admired it so Grant presented it to him. Later, Grant told me that the author resold it for $125.00. Grant said he would be careful of gifts in the future.

Bruce and Grant became more than "architectural and decorating friends." Bruce was like a brother to Grant; this is indicated by an incident which Bruce recalls:

66

All artists are, I suppose, after they become famous, pursued by queer people. One afternoon Grant called my office and asked me if I would stop in on my way home. He stated that he wanted to show me a painting he was working on. However, when I arrived at his studio, he had no thought of showing me anything and was peculiarly agitated. After I sat down he got to the point immediately.

"I had a caller this afternoon," he stated. "I heard someone at the door and there stood a young fellow nineteen or twenty. He said he wanted to talk to me privately. I asked him in and he then informed me that his mother had told him before her death that I was his natural father. I asked him his mother's maiden name and it's one I never heard of before. I told the boy that I had never heard of such a person, but I didn't seem to convince him. He also told me he was an artist and wanted to study with me. I got rid of the boy as quick as I could, but he says he's coming back to see me. It's got me worried."

I asked him what the boy looked like. Grant said he was about six feet tall, very thin, with long black hair in need of cutting, black eyes, dirty clothes in need of pressing. I started to laugh at the idea of his being the father of such a type. Grant looked at me in a puzzled manner, not fully understanding my amusement.

As far as I know, Grant had discouraged the boy sufficiently, for he never spoke of the matter again.

Later Bruce wrote: "The Robert Armstrong house which was featured in *Arts and Decoration* was given in construction detail and design. This was in the start of the New Deal time when Iowa corn was selling for ten cents a bushel and Grant Wood was ending his career as a struggling artist and decorator, part time. I happened to be, with Grant, the designer and builder."

The house was built of good limestone in natural color, reminding immigrants to Iowa of old Pennsylvania fieldstone houses. The site, twenty-two acres, then four miles from the city of Cedar Rapids, was a flat front on a high elevation rolling gently off to the back, deeply wooded in the rear. It immediately caught the eye of Grant Wood. And for the four of them—Robert and Esther Armstrong, Bruce, and Grant—the idea of the old-stone-house type was perfect to their agreeable and united thought.

The plans were worked out through their visits to old houses, noting details of paneling, simplicity of fireplace design, wall surfaces, doorways, cornices, chimneys, and the general "mass." Esther recalls what a wonderful experience it was for her and for Robert to junket around the countryside with these two brilliant

minds, such good company, such fun, and there was never an argument—the four of them could reach an agreement in no time. They were, of course, not new friends, but old ones. Robert's name is on those early Art Association lists.

The front door of the house was recessed, and it took a derrick to get the stone lintel up atop it. Because Grant refused to have any lights extruding from the house, stonemasons chiseled holes for recessed lights. And Bruce told of climbing up outside a window, calipers in hand, reaching out to measure "a gem of a cornice" while Robert, Esther, and Grant held their breath below. The trim of the back porch was arched—not a straight line.

An old "ridge road" which had been used by the early pioneers who drove their wagons all along the ridge on their way to the village of Cedar Rapids from Prairie du Chien, Wisconsin, ran through the property. The road is now walled on one side for spring bloom, and on the other for fall flowers, rather following the sun.

When it came to the interior, Esther knew exactly the size of the rooms she wanted, and she drew them out on a thirty-second-of-an-inch scale, and the boys drew the plans from that.

Jay Sigmund, who lived in Waubeek and was a friend to them all, gave them many historic details about old places. It was interesting to see how their forefathers had had a penchant for cupboards and cabinets, recessed into paneled walls in every room possible. These cabinets were used all through the house. Iron hardware, with steeplechased pins, and white china door knobs were also used throughout. The solid walnut banister rail was a handmade copy of one in an old inn. Battens were used in the front entryway, and molded plaster circles surrounded the ceiling lights.

The house is furnished, of course, with early Iowa antiques—many of which had come to Iowa in covered wagons. Stenciled yoke chairs, peculiar to the Midwest and difficult to find today, are here in profusion, as are the treasures from the Iowa Amana Colonies, many of which were brought here from Ebenezer, New York, the temporary colony in the 1840s. The soft gray-green carpet used throughout the downstairs was especially woven from a design created more than a century ago. Wallpapers of old design were carefully chosen to fit the early period.

68

With all its accuracy of design and furnishing, the house is very comfortable, livable, and elegant. Robert and Esther—their four daughters married and away from home now—are living there very happily still.

Bruce was later to write: "This was the last house we were to work on together. At that time I thought it was just another in a long line of work we had done and that our association would go on into the future. But Grant painted *American Gothic* and *Stone City* and fame was plucking at his sleeve."

The Little Gallery

In 1928 Cedar Rapids was chosen as a city with an art association worthy of support from the Carnegie Foundation which granted fifty thousand dollars to be used for underwriting art education and organizing and sending out traveling exhibits. Cedar Rapids was one of the earliest midwestern cities to be selected for this honor. This was a tribute to the Art Association and its support of local art, as well as imported art.

Edward B. Rowan was assigned the directorship by the American Federation of Arts, the administrators of the grant, for a period of five years, his work to be the exhibiting of traveling collections, the promoting of art appreciation in the community, and the encouraging of local artists by showings of their work.

Mrs. Austin Palmer, whose fortune came from the Palmer Penmanship Method, gave her home on First Avenue for use as the new Little Gallery, and the entire community was consistently invited to the exhibits and the parties there. Ed Rowan and his wife Leta were gracious hosts and were very soon well known in all circles of the city. Ed Rowan was a young man, his wife attractive, their two sons popular. Ed was painter enough to be in some exhibits with the other fellows, and he had the ability to make friends for the Little Gallery. He was generous with his time, and lectured and talked to students.

The Little Gallery benefited the community, and it also benefited Coe College, located less than four blocks away. Both faculty and students used and enjoyed it.

The new gallery opened in 1931. Like the home it occupied, it had many rooms, sections upstairs and down for grouping exhibits: the Hall, the Palmer Room, the Fountain Room, the Front Room, the Print Room, the Children's Room, the Better Homes Room, and the Creative Writers' Case.

Ed Rowan must be credited with cooperating with the people

70

of the community and, in turn, gaining their cooperation toward making the Little Gallery a showplace for all kinds of creative talent in the community. Ed himself spoke of the splendid encouragement he had had from Bruce McKay and George Keeler, noted for his work in wrought iron, who left his studio in Chicago for two weeks to devote himself to this hometown project. Those who put aside other things to help ready the Little Gallery included Grant, Arnold Pyle, Marvin, and Adrian Dornbush.

In its earliest days, the Little Gallery offered many excellent traveling shows. Local artists were also featured, but Grant felt, at one time, that enough was not being done for local talent. Grant, as usual, sought the best in showing for all the painters of the community, especially those not so well known, and Grant seemed to feel that when he suggested a full local exhibit, Ed had put him off. He promised, but when nothing materialized, Grant was irked.

At coffeetime in Hobby House, Grant complained about Ed Rowan—how Ed was turning his back on the boys and how Ed did not have time to talk to him. Over a period of several weeks, we listened, sympathized, and worked up a slight thing about Ed Rowan ourselves. Characteristically, Grant had to do something about it to get it out of his system. And he had some luck. One afternoon he came into the shop and looked long and hard at Mary.

"Mary, I have an idea for a picture."

"Well fine, but don't look at me!"

"I came across a teacher over at Grant School who looks exactly like Ed Rowan. And you fit perfectly into my idea."

The picture we saw and knew as *Appraisal* showed a farm woman in ragged sweater with a Plymouth Rock hen under her arm stooping, or rather cringing, as she appraises the tall, haughty woman in whose hands a purse drips money. There was no mistaking the face on the farm woman; there was no mistaking Mary, either.

But an unusual thing happened. Mary is no longer here to back me up, but during the picture business Mary suggested to Grant that he go to Ed, pin him down, and refuse to take "no" for an answer. "He's busy, Grant, and those traveling exhibits keep coming in. But please, try again and stick with it!"

Evidently, Grant did just that, for the next time he was in

he admitted he had followed Mary's advice, and said, "Now I want you both to forget everything I said about Ed. We're friends again and understand each other. And he is going to give the boys an exhibit." We were terribly glad there was peace between these two fine men. And the picture which now appears as *Appraisal* shows a tall, erect, good-looking farm woman, neatly dressed, eyeing that dripping purse in the hands of the haughty woman. We never knew what happened, but it was so like Grant to soften his "appraisal" after the peace pact with Ed.

Grant once asked Mary if she minded what he had done to her. Mary replied, "No, Grant, I don't. But I could use that purse with the money in it if you would give it back to me!"

Outstanding in the Little Gallery was a wrought iron banister designed and executed by George Keeler. George was rated by the Art Institute of Chicago as one of the three outstanding artists in his field in the Midwest. Five photographs of his work were also on exhibit, including a pair of gates of forged iron done in the Italian manner, a pair of polished forged steel gates of contemporary design, a cross done in the Celtic manner, a grille of forged iron in the Gothic, and a railing of polished forged steel of contemporary design. Windows of hammered leaded glass and the design of the lighting fixtures in three of the gallery rooms were also his.

Grant designed the modern showcase in the Reception Hall, and had chosen and arranged the furniture, rugs, wallpaper, window hangings, and accessories in the Better Homes Room, an effort on the part of the gallery director to cooperate with local merchants in displaying choice merchandise. This room was to be completely redecorated every four weeks. The first room done by Grant was in Early American style, tending strongly toward "farmhouse colonial."

In an early exhibit, Grant was represented by three large paintings not previously shown in Cedar Rapids, and by a number of small sketches. The paintings included a portrait of his sister Nan, *Arnold Comes of Age* (we remember this originally as *Adolescence*), which was on loan from the University of Nebraska, and *Appraisal*. Adrian Dornbush, who conducted a series of classes in drawing and painting in the gallery and who came

to Cedar Rapids after a year as director of stage design with the Kansas players at the University of Kansas, showed three spirited watercolors. Marvin had two oils in the show—a large decorative landscape and a small still life—as well as a pencil drawing of Winnifred. Other exhibitors included: Herbert Rosengren, who showed his prize watercolor, *Iowa Tobacco Field,* another watercolor and several etchings; David McCosh, who showed *White Mill,* which had recently won an award at the Art Institute of Chicago, and some of his watercolors; Edwin Bruns, who exhibited an oil of his wife and their three children; Leon Zeman, who showed two portraits of Tama Indians and his prize-winning portrait of his wife Mary; and Nancy Finnegan, who displayed her oil *Peonies.*

Charles Keeler, already an internationally known etcher, showed his *Levanto Rivera* and *Old State Capitol,* and his famous aquatint, *Street of Life and Death.*

John Barry, photographer, exhibited a group of black and white prints. Nan Wood Graham displayed embossed leather, as well as several paintings and a piece of sculpture. Barbara Warren, who was skilled in the lighter metal crafts and was scheduled to teach a class that winter, exhibited some of her work. Handbound books by Mrs. George B. Douglas were also displayed, and Louise Crawford, already a widely known musician and composer, presented "Two Melodies for Violin and Piano," the anthems, "I Saw Three Ships" and "How Sweet and Silent is the Place," and several others. Published works and original manuscripts by Jay Sigmund, Mildred Fowler Field, Jack Beems, Luther A. Brewer, Paul Engle, and Robert Gates represented the creative writers of Cedar Rapids.

Grant could find no fault with this exhibition. Probably, Ed had always intended to support the local talented people in all the arts, but he had a duty, and "shifting exhibits is just somewhat more difficult than shifting scenery," I am told.

A later exhibit, held in 1933, while Grant was still living in Turner Alley and painting there, included the following work: two of Grant's oils in the Hall; lithographs by Russell Green in the Palmer Room; oils by David McCosh in the Fountain Room; oils by Marvin Cone in the Front Room; watercolors by David McCosh in the Print Room; twenty-five paintings used for Red Cross magazine covers in the Children's Room; furniture and ac-

cessories chosen by Maud Whelihan in the Sun Room; and prose writing by Ruth Suckow of Des Moines in the creative writing case.

Grant's two oils shown in this exhibit were *Herbert Hoover's Birthplace* and *Daughters of Revolution.* Shrieks and howls about both of these paintings had been heard from afar, and now the home folks had their turn to raise their voices, never realizing that these two paintings would probably never be shown in Cedar Rapids again.

Stone City

Stone City, overlooking a sheltered valley of the Wapsipinicon River, was three miles from Anamosa, Grant Wood's boyhood home. When Grant painted Stone City in 1930, it had not been touched for many years—not since the dramatic arrival of cement on the construction scene. But the activity of quarrying limestone, in the era before cement, was great and prosperous, and the head of the business in Stone City had built a proper mansion up on the hill, looking across the quarry and down into the valley. Where the workers had lived there was ploughed ground.

Grant set up his easel on high ground with a corner of the old mansion in view—the foreground before him sinking down deeply and then rising again. In his painting, the up-and-down road seems alive. The famous "globular" trees are there—the "tree" idea from "my mother's old Haviland China" of early days spent on the farm not too far from this dramatic scenery.

Stone City was a favorite spot, and the deserted mansion was an invitation to something. Grant still held to his idea of a true artists' colony, a sincere and productive one, where artists could live and work and mingle. Turner Alley had fizzled, and Studio House had had only a short life. Now, here, was Stone City, almost too ideal to be successful, but the perfect expression of Grant's dream.

The idea of using this deserted stone mansion and its sustaining building as an artists' summer school and colony was carried out by the artists themselves. They had the energy, the imagination and wit—plus the inspiration of Grant Wood—to make Stone City something of great glory. In 1932 and 1933, it was a blazing spot for artists in the Midwest, and writers and reporters found it colorful copy.

The files of many newspapers, far and wide, tell the amazing

75

story of Stone City. The ice wagons were an example. Miss Grace Boston, a secretary by profession and an active figure in business and professional women's circles, was the business manager of the colony. She told reporters of her visits with Mr. Chadima, the "iceman," persuading him to let the artists have the old ice wagons no longer in use for housing at Stone City. She got permission from Cedar Rapids to tow them across the river. They were pulled the 20-odd miles to their new location, presenting a colorful and astonishing spectacle on their "safari."

No less colorful are the stories of how these wagons were adapted as homes for members of the permanent staff. Newly roofed and painted, they were arranged in a string from the Old Stone Tower to the mansion. The red lantern hanging from one of them was hooked to what had been the place for the driver to hook his ice tongs. Flower boxes and wren houses (in the metal pocket where ice books were kept) made the exteriors gay. Grant, as faculty director, had an ice wagon to himself, and he painted a mural on the outside—a buck deer poised on a pillar of stone, an Indian on another, with snow-capped mountains in the background. The whole appearance of the ice wagons pleased everyone with the suggestion of the gypsy life, bizarre, and nomadic, and Ed Rowan concluded that the ice wagons were fulfilling their undreamed of destiny. The mansion, with its large rooms, full-length windows, carved marble fireplaces, and ornamented ceilings—all proper Victorian—was of course headquarters. The third floor was a dormitory; the second floor had rooms for women. Classrooms, dining room, kitchen, and recreation areas filled the remainder of the house. The lithography and picture framing shops were in the basement.

Adrian and Grant leased a ten-acre tract of the property, which included besides the stone mansion, several other stone buildings which were renovated and equipped for their use. The combined hotel and opera house which had been the envy of the neighboring settlements when it was erected by the quarriers became an exhibition hall. Its earthen floor, wagon-wheel chandelier and villainous painting of the traveling salesman and the farmer's daughter on one wall gave a very "Bohemian" appearance. Beer was served over the rough-board counter and mugs, flagons, and goblets lined the walls.

If the recorded history is true—and its source is anything but

suspect—Stone City had all the coloring, frivolity, and trappings of imaginative artists. But it also had an atmosphere that made it a school to which mothers were quite willing to send their daughters to paint—in good company.

One hundred twenty students lived there the first summer, fifty of whom were on the grounds at any one time, most of them in overalls, as was Grant, of course. John Curry came down from Wisconsin, put on his overalls, painted, and went out to tell the world it was as fine a thing of its kind as he had ever seen or dreamed of. "It's the biggest project of its kind in the country today," he told reporters. To me, John was one of the big attractions.

Adrian Dornbush, a Hollander, handsome, earnest, energetic, had taught in Missouri, Michigan, and Kansas, and was instructor at the Little Gallery during the winter. Adrian became director of the colony in its second summer. The project had lost money in its first year. Although it had never been the object of its founders to show a profit, it was necessary for the colony to be self-sustaining. Grace lacked the organizational and managerial qualities necessary.

Winnifred says that Adrian was a better "organizer" than Grant, and that the two of them together made a perfect team. "Marvin and I both admired Adrian very much, and were very fond of him," she said. "He was the strong reed in the fabric of the Stone City Art Colony." The fact that Marvin taught there indicated his wholehearted approval. He loved the place, liked the students, and enjoyed the whole company tremendously.

More students came the second summer. The six-week courses in life drawing, figure and portrait outdoor painting from life, color theory, sculpture, sketching in oil, watercolor, composition, and metal crafts were accredited by Coe College. Besides the accreditation by Coe, the colony was sponsored by the American Federation of Arts, through the Little Gallery in Cedar Rapids, and by the Iowa Artists Club. In addition to Marvin, Grant, and Ed Rowan, the faculty included David McCosh, Florence Sprague of Drake University, and Arnold Pyle. Tuition was $40 for six weeks, or $7.50 by the week. Private instruction was $4 an hour. Dormitory space was $6 for six weeks, or $1.50 per week, or 50 cents a day for camping space. Board was $8.50 a week for "excellent cuisine."

During that second summer of 1933, a course in stone chiseling was offered, and Charley Mercer, an old-time quarry worker, superintended the collection of white limestone slabs from the hills. A course in lithography was taught by Frances Chapin of the Chicago Art Institute. "The exclusive residential section of Stone City, Wagon Row," became common talk in the press, and the colony was on its way to becoming internationally famous.

To me, the presence and enthusiasm of John Steuart Curry was one of the colony's big attractions—John, who looked so much like Grant in height, width, shape of head and face, and roly-polyness. In clothes—overalls and white shirt—even in general expression, the two were very much alike. Some smart fellow said he could tell the difference between Wood and Curry—Curry always smoked a pipe, and Wood had that everlasting cigarette sending up smoke. Both were devoid of affectation with no artist's window dressing about them.

Visitors overflowed the grounds on Sundays, and country programs were popular entertainment: accordian, dulcimer, and fiddle duets. Jay Sigmund, acting as master of ceremonies, would read some of his poems. People came from miles around. In the Wapsie Valley, they still talk about it as if it must have been a dream.

The colony gave a promise of permanence, and Grant hoped that in four or five years, we would see some very definite results from the project. But the second year, 1933, was its last. Grant was becoming more famous, and with his marriage to Sara Sherman Maxon, he moved out of Turner Alley to another kind of life in Iowa City.

Life in Iowa City

On February 2, 1935, David Turner received this letter:

Turner Alley
Feb. 2, 1935

Dear Dave:

I hope that today's news won't be too much of a jolt for you. But Sara and I both hated the thought of the uproar that an announcement of our engagement would make, so we kept it quiet. We are being married this evening in Minneapolis.

This is no hasty decision on our part—we have been considering it seriously for many months and I am sure we are making no mistake. Musicians and Painters are, as you should well know, having harbored me so long, darn quiet people. They take a rather special understanding and because we both of us need and both of us have just that, I am convinced we shall be very happy.

I'd have liked to have given you and some others advanced notice of what was about to happen, but was afraid there might be a leak somewhere. Feeling sure that you will understand.

Sincerely,
GRANT WOOD

Never before in his life had Grant ever signed himself anything but "Grant" to David Turner.

To us who knew Grant, this letter was not only *not pure Grant,* but had the strong intimation that Sara's opinion was going to prevail—Sara's influence was to dominate Grant—and that a wedge between Grant and David Turner had already been driven.

When Sara Sherman went to Chicago to study music, the community took it as a matter of course. Her mother had directed light opera in Cedar Rapids and her sister was considered

a very fine piano teacher. Nor were they surprised when she caused musical comment as a fine contralto on the concert stage. Later, in New York City, she became interested in light opera, playing roles there as a better-than-average contralto. She also appeared in folk song recitals in the East and won quite a reputation for *lieder* singing. Even in Iowa, she had directed the Women's Club chorus, the Jones County Farm Bureau chorus, and had given lessons in singing. She "worked" away from home, came home when out of a professional assignment, "worked in the community," and went back again, seeking what she naturally wanted—prominence which her ability deserved—in the field of music.

Sara was able, well liked, made friends with people, and could direct them. It is assumed that in her own mind all this was secondary to her never-flagging ambition to reach the top, to perform on the concert stage. That she had "bad luck" might well have been due to the Depression, when many gifted people were having difficulty getting top jobs.

She did, however, get a part in the light opera, *Robin Hood*, and was even allowed by the composer, Reginald De Koven, to sing for the first time on the stage, as a solo, his *O Promise Me*. Her company was one that took to the road, to the North Western Railroad, to the usual—inevitable—one-night stop at Greene's Opera House in Cedar Rapids. It is generally reported that she appeared in tights. I have no confirmation of this, but she did appear alone, in her costume of the play, and sang her solo. Light opera and *Robin Hood* were popular enough to be sent on the road, but it was a rare event to have a local girl of a well-known family appear in a professional troupe. The local reaction was amazement, disapproval, interest, and a shout of glee to have some "gossip to talk over." Evidently, Sara herself was to feel the full force of the "disapproval," rather than the more pleasant reactions. She was joked about, made fun of, laughed at, all over town, and her evident resentment of what she considered "a small-minded, middlewestern" reaction went very deep.

Possibly, if Sara had had no family in Cedar Rapids, or if her family were not well known and highly respected in the community, the audience could have laughed its head off and it would not have mattered to her. But this competent, handsome woman, who considered herself an artist, may have felt, as the town did,

that light opera was a comedown for her talents. She had been frustrated by circumstances which she could not control, even though she had worked very hard—and had been temporarily successful. However, she had not reached the heights in musical circles she felt she deserved, and as the community said, she was "on her uppers" when she came home to live with her sister Phoebe Haman, the wife of a prominent Cedar Rapids banker.

One day, Sara came into our shop. She seemed somehow familiar yet neither Mary nor I actually knew her. White-haired, beautifully groomed, blue-eyed, she smiled at us and introduced herself as Sara Sherman Maxon, Phoebe Haman's sister. We were alone in the shop so we chatted a bit. As she turned to leave and we turned back to the office, she asked to use our telephone if she might. And then, sitting on our telephone stool, she said to us, "Surely you gals have a list of the eligible men in town haven't you?" We laughed and joked about this one and that one, and she left.

This was after the purchase of, and the storms about, *American Gothic*. Grant was involved with other painting and getting one kind of attention or another, increasingly, from many parts of the country. He was flooded with mail and requests for interviews, lectures, radio talks, and so on. We hadn't seen him for some time.

Not too long after this visit with Sara, we saw Grant waiting in his car outside a delicatessen, and we stopped to visit with him. Sara came out of the store with two large filled bags, got into the car, and they said goodbye to us and drove off. After that it seemed that we heard frequently that Grant and Sara were seen here or there, and evidently gossip reached Dave Turner.

One day Dave looked over at Grant's studio and saw Sara, a blue scarf tied over her white hair, busily cleaning the studio windows. He was shocked, and lost no time getting Grant into his office and evidently, quite bluntly, said, "Grant, you've got to get that woman out of your studio. You can't have her around working over there!" Grant probably explained how useful she had been to him, and to his mother, who had been ill, and he finally said to Dave that Sara was terribly *misunderstood!*

She was a good housekeeper, an excellent cook, an orderly person, and she was kind to Mrs. Wood and cared for her plants, and no doubt, helped Grant. It all fitted neatly and seemed a

81

wonderful situation. Very evidently, Grant had fallen in love with Sara Sherman Maxon and, as Mary said to me, "She found her eligible man."

Grant and Sara were married at the home of Sara's son, Dr. Sherman Maxon, who, with his wife, were their only attendants at the service performed by the pastor of the Minneapolis Congregational church. The press sketched the biographies of both of them, concluding that they both were artists, spoke the same language, and should have a congenial and exciting life ahead of them.

Winnifred and Marvin wholeheartedly believe that Sara had all the talents necessary to create a beautiful home for Grant and that although she graciously entertained his old friends, she did try to break him away from most of his friends in Cedar Rapids. They felt, as we discussed this many years later, that her resentment of the community went very deep and that Grant was to be the tool with which to "punish" Cedar Rapids. These feelings were in many minds, but there was no reason at the time to put them into words. Only much later were these feelings voiced by any of the circle of Grant's friends.

David Turner was evidently Sara's first target. She told Grant, and she told Dave (with Grant apparently concurring), that he had ruthlessly exploited Grant by buying up all his early paintings at a very cheap price, knowing that eventually they would become very valuable. The real story, related earlier, is the truth, but Sara had confirming evidence to support her version in the fact that David Turner, always, a booster for the Art Association, wrote, in the publicity for an exhibit of local painters, that people "should be sure to see the exhibit, consider buying a picture, not only for the pleasure it will give them in their homes, but because these paintings are comparatively inexpensive and will increase in value as time goes on, a good investment in pleasure and in money." Sara pointed out to Dave, and to Grant, that that was exactly what Dave himself had done with some forty or so of Grant's early works.

Grant's Iowa City home, at 1142 East Court, was an old Iowa mansion built by a brick manufacturer who "didn't stint on

82

the brick," as Grant said. Adeline Taylor in the Cedar Rapids *Gazette* spoke of it as "the shabby abode of a number of families, an Iowa colonial home, more true to the period than the original builders had made it." The house that Jack built had nothing on the house that Grant Wood was building in Iowa City, according to Adeline. Grant himself, juggling doors, windows, walls—was "practicing fairyland fiction on an 80-year-old house, in the making, the new making."

The easier way is to build a new house, but that would never suit Grant, to whom architecture and craft work were not new at all. He was teaching in the morning, writing on his autobiography in the evening, and keeping one jump ahead of the carpenters the rest of the time—all this around the clock.

The house, remodeled, had two apartments, one upstairs and one down. Bruce McKay made several trips to Iowa City to assist Grant with his work on the house, where structural changes were under debate. He speaks of the "shining brown linoleum in the hall, the wall of wallboard with 'V' joints, the old walnut stair rail, the iron fireplace in the living room with the painting of Nan over it. Around the edges of the window grew ivy from his old Turner Alley days. Rose wallpaper and white walls, dark brown carpet, easy chairs—a place of warmth and welcome."

Our friends in Iowa City could not speak enough of the exquisite, unostentatious detail, the period perfection of construction and furnishings. Grant loved perfection, yet, rather than create merely a showplace, he reached for harmony and *comfort*. Sara was a good housekeeper and, without doubt, in the glass they loved to collect, in the detail of furnishing, in the ability to make it correct but livable, she was indeed an artist herself. The press noted, "There was an extraordinary community of taste between Grant and his wife." Grant himself was quick to point this out when complimented on the beauty and "livability" of the two apartments.

Grant consulted Mary about lampshades—her specialty. The shades were made to order and Grant and Sara came to pick them up with seeming good nature. Grant was very pleased with them. We were to see him only once again in his lifetime.

The piece of furniture that Grant had to *make*, to get one to suit him, turned out to be a venture in patented furniture selling and distribution. It all came about when Grant wanted a chair— "one that doesn't rise up around me like a feather bed, a comfort-

able chair, but not too soft." Failing to find one on the market, he designed one with the help of Henry R. Lubben, a furniture dealer in Cedar Rapids. It was beautifully proportioned with a rolling headrest and gently curved arms, comfortable as an old shoe yet with lines that harmonized with the antique furniture of the new home, where it was placed in the corner, near the bookshelves that went from floor to ceiling. Upholstered in a small-figured brown antique-type material to blend with the carpet, Grant's chair had a deep-tufted seat with no cushions, and the roll of that head rest was comfortable for lounging. Not too hard, not too soft, one could emerge from it with little physical exertion and without the aid of a derrick.

A long ottoman curved at the outer ends was planned for use with the chair. When the two pieces were pulled together, Grant had a chaise longue. Around the chair legs and the bottom of the ottoman, too, was a wide fringe. The ottoman, independently, could seat two people. Henry applied for a patent and eventually notified Grant that "The Grant Wood Lounge Chair" was registered and patented by the U.S. Patent Office. The advertising suggested "No Derrick Needed." But even previous to this, there had been an arrangement for more extensive manufacture and distribution.

In the scrapbook at the mortuary a picture of Grant in his famous chair shows him wearing a big smile, and holding a cigar! The caption reads: "This Chair Was Conceived in Comfort and Dedicated to the Principle of Utter Relaxation. I hope you like it." This caption, I believe, was on the tag attached to each chair sold by Henry Lubben.

Grant also designed the small, three-legged pedestal table that had a walnut picture frame for a top. The oval top of an antique "parlor table" served as the top of a coffee table, and he built shelves underneath, in the modern manner. *Gazette* writer Naomi Doebel noted that his "pride and joy" was the quaint walnut hall cabinet built to hold overshoes and rubbers. A deep, hinged drawer, a reminder of an old flour bin, pulled out to reveal a container lined with galvanized iron.

The upper apartment in the new home was to be Grant's mother's. Mrs. Wood was not at all well, and while Grant and Sara were finishing the work on the house, she stayed with Winnifred and Marvin. Winnifred, who had always loved her,

84

A Portfolio of the Art of
GRANT WOOD

WHILE GRANT WOOD painted, almost legendarily, in his Cedar Rapids loft studio he was not the isolated artist such an image evokes. Wood was very much involved with the life of the community, and the people of Cedar Rapids were very much involved with him. This is the story focused on in this book and this portfolio of Wood's work.

True, many of the great masterpieces which came into being at No. 5 Turner Alley can no longer be seen in Cedar Rapids. But that unique residence is still very much as Wood left it, and dozens of fascinating examples of the many-faceted art of Grant Wood are in the public and private collections of the people of Cedar Rapids.

Perhaps, more importantly, the creator of *American Gothic* is much less an enigma in his hometown. He is the likeable young teacher who went off to Europe to paint, and who returned home with packets of charming paintings with great promise but not quite yet Grant Wood. He is the Grant Wood who saw the same everyday scenes all the townspeople, in his time saw, but who perceived dignity and beauty in an old stone barn, the draft horses that used to move along the main street, and a pair of his own soggy worn shoes. He is the friend famous for practical jokes and kindly good humor—the man who caricatured a prominent local citizen as a nude Bacchus perched atop a fountain of champagne—and the town "character" who designed the ingenious clock door, which told visitors to his studio his whereabouts. He is the painter who rarely accepted commissioned portraits except for a special reason but whose portraiture has gathered much critical acclaim. He is the searching artist who, in *Return from Bohemia*, portrayed himself painting among the people he knew best. And finally, he is the humble success seen in the lithograph *Honorary Degree*, always a favorite of his friends for it shows that Grant Wood did not take himself, or his fame, too seriously.

In addition to the paintings and other Wood works remaining permanently in Cedar Rapids, the city's Art Center, so intimately connected with the life and art of Grant Wood, has become a natural gathering place for periodic exhibits of his works. They continue to come home from New York, Omaha, and other parts of the country, and growing generations of Cedar Rapids citizens get to know Grant Wood as their fathers did. The tradition, "the heritage," of Grant Wood remains strong today in Cedar Rapids. In a very real sense, this community and this artist belong together, and together they stay in many, many ways.

Ironwork, ca. 1920
Designed by Wood;
executed by George Keller
Shown in Cedar Rapids, 1972

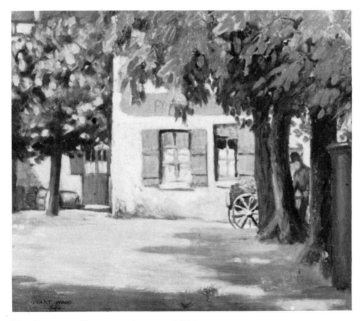

The Square—Chatenay, France, 1920
oil
Mr. and Mrs. John B. Turner, Cedar Rapids

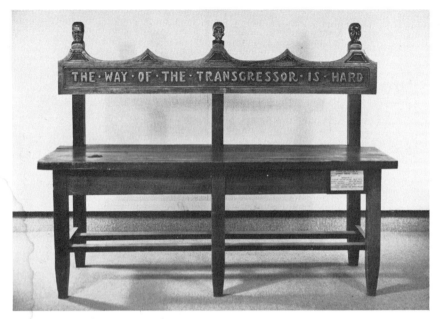

Mourner's Bench
Carvings by Grant Wood, 1925
Cedar Rapids Community School District
On permanent loan to Cedar Rapids Art Center

Old Shoes, 1926
oil
Mr. and Mrs. John B. Turner, Cedar Rapids

Overmantel Piece, ca. 1926.
oil
Home of Mrs. Herbert Stamats, Cedar Rapids

Charles Munson,
president of the
Cedar Rapids
Chamber of Commerce,
as Bacchus, 1928
black and white chalk
on paper
Mr. and Mrs. Peter O. Stamats,
Cedar Rapids

Draft Horse, 1932
Pencil on brown wrapping paper
Mr. and Mrs. John B. Turner, Cedar Rapids

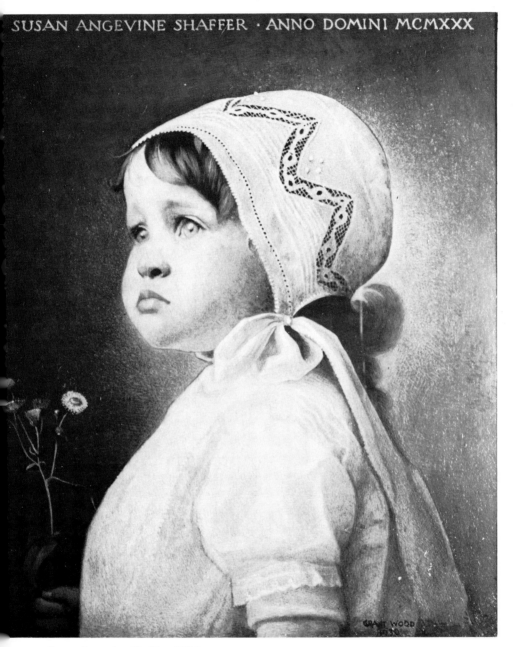

SUSAN ANGEVINE SHAFFER · ANNO DOMINI MCMXXX

Susan Angevine Shaffer, 1933
portrait, oil
Van Vechten Shaffer, Cedar Rapids

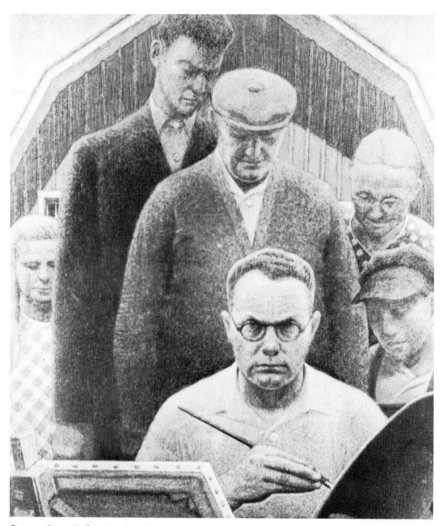

Return from Bohemia, 1935
pastel
IBM Corporation, New York
Shown in Cedar Rapids, 1972

"Spilt Milk"

"Saturday Night"

"Popcorn for Grandpa"

"Pets on the Farm"

Drawings from **Farm on the Hill** by Madeline Darrough Horn
(Charles Scribners Sons, 1936)

The Good Influence, 1936
Illustration for Limited Editions' **Main Street** by Sinclair **Lewis**
pencil and watercolor on gessoed masonite
Pennsylvania Academy of Fine Arts, Philadelphia
Shown in Cedar Rapids, 1972

Honorary Degree, 1937
lithograph
Mr. and Mrs. Robert C. Armstrong, Cedar Rapids

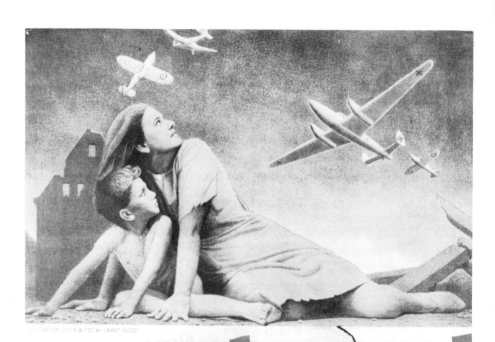

World War II Allied Aid Poster, 1940
colored lithograph
Joslyn Art Museum, Omaha
Shown in Cedar Rapids, 1972

said she was a delightful guest, and they enjoyed so much having her with them.

When the house was ready and Grant came for her, he stood in the living room, talking with Winnifred. When his mother, slowly coming down the stairs, reached the point where she could look into the living room and see Grant standing there, she said, "Grant!" And Grant said, "Mother!" And Winnifred told me that she will never forget the emotion and love conveyed between the two, in those two words. Mrs. Wood lived only two weeks in the new house in Iowa City.

Grant Wood had started his work in Iowa City before actually moving there as a part-time lecturer, working with thirty-four artists in the P.W.A.P. administration studio in Iowa City. The studio was an old, empty swimming pool, with plenty of space and a good north light. Then Grant commuted the twenty-eight miles from Cedar Rapids three afternoons a week.

During the 1930s, artists were glad to get any kind of work. There were, thankfully, for the group in Iowa City, "commissions"—murals in panels for the library of Iowa State College at Ames and four large mural lunettes for the Public Library in Des Moines. These and like projects were gratefully received and happily executed. The mural for Des Moines was never finished, but other school murals all over Iowa were completed.

Dr. Elizabeth Halsey, head of the physical education department at the university, had met Grant in Cedar Rapids, very possibly in our shop. She wrote:

When he commuted to Iowa City, I used to pick him up and take him to the campus; I'd go sit in the old, dry swimming pool and watch him paint, getting his Ames murals going. Background study was prodigious. One frame showed a plowing scene at the time of the Civil War. A young artist on Grant's mural-team looked up plows of that period in historical references. He then constructed a small model and used it to actually plow a bit of Iowa soil. Then this miniature plowed field served as a model for the large mural painting. I remember someone asked Grant why all the bother, since a plowed field was a plowed field in 1860 and now. "No," Grant replied, "the furrows are different and we want to be as honest as we can."

I remember discussion from that workshop. Talk drifted around to the murals of Diego Rivera, who was an early proponent of distor-

85

tion. Why distort? Grant was asked. "As I see it," he said, "an artist has something to say in his work. If the non-reality says it better, that's useful, but if the non-reality is so great that it alone becomes the focus, that's not so good."

He went on to tell of an incident which happened when he was working on his well-known "D.A.R." painting (so-called). In his pursuit of honesty he collected photographs of officers of the organization from some years back, up to the present. From them he had composite photographs made, and these served him as models. One day the finished painting was viewed critically by one of his young friends in the neighborhood. "Mr. Wood," said the boy, "there's something wrong with this picture. All those women's mouths are exactly alike!"

Maybe this boy had something, Grant thought, and changed some of the mouths. "Then," said Grant dramatically, "my painting was gone—aboslutely gone! So of course I put the old mouths back again, and there was my D. of R. again."

When Grant established a Saturday afternoon critique of amateur paintings, he held it in one of the medical amphitheaters. Anyone—town or country, student or housewife—who wanted his work reviewed was welcome to bring it. And anyone who wanted to *listen,* could come. So there was always a full house of auditors, the front rows filled with painters clutching their paintings. It was soon obvious to those of us in the back row that this man was not only a good artist, he was an artist in his teaching.

Probably no soul came with a painting and left without some kind of encouragement. We were told by some of them in fact that they couldn't wait to get "at them" again, the same painting or the same problem. We always wondered how he did it.

I remember a terrible botch of colors on one canvas. As he held it up, my friend said, *sotto voce,* "What in God's name is he going to say about this one?" I looked quickly from the blob to Grant's face, imperturbable in its ruddy good humor.

"This person is absolutely right in feeling that color is important," he began. "Now there are problems here in the *choice* of colors. Perhaps he could use better contrasts among the complementary colors. And then when he has his forms more clearly in mind a very interesting possibility may develop."

Grant's painting of the rolling Iowa fields gave me a new sense of the richness of the state. As I drove the highways I saw it all with new eyes. I told him so and I think it pleased him to know that his saga of the fertile country had made its mark. I am glad I told him.

Dr. Halsey's feeling about Grant's "saga of the fertile country" was not shared by everyone. Some Depression-era critics jumped on him, one reporter saying that an honest painter

has a credo that holds good for such personal experiences as hunger, living at home on relief, selling apples, getting clubbed by police for

refusing to starve, knocked around from one tenement flat to another, hay burning, corn burning, land taken out of production when people are hungry, put in jail for stealing bread for starving children, burning of wheat, shooting of cattle. . . . Let radical artists concern themselves with forced sales, with strikes, foreclosures, and so on. It is none of Mr. Wood's affair. He "understands human reactions." He realizes that people like to buy nice, pleasant pictures, and that's what he's giving them, very charming, decorative, too.

He knows how to draw, has a good sense of color and composes with skill. His pictures are very popular with the substantial well-to-do people who can afford to buy them—and for as little as $600, or larger, for only $3,000 or thereabouts.

Fan Prescott could have answered those arguments then, as she does now, by reminding us that Grant's area did not suffer these extremes as other parts of the nation did. Very underprivileged children were in his classes, and relief families represented there, but they were not destitute or starving. Fan knew Grant as a teacher, and he taught his pupils to do things with their hands, to be useful, to use their imaginations. He gave children ideas, then left them to work them out, allowing them to develop self-reliance and creative use of their brains.

All Grant's painting had man, seen or unseen, making use of the land, using it for his living, and caring for it. The farm children are busy; the farm home is "hand-operated"; people are making do with what they have. It is not a horrific truth, but it is truth just the same, and a positive truth.

In July, 1934, the summer before his marriage, Grant was made an associate professor of art, an appointed member of the university faculty with a salary of $3,600 a year. He bought a car. Before this, he had covered the miles to Iowa City on the Interurban Railway, which clattered across the landscape daily. During this period, demands for lecture tours and appearances at exhibitions were steadily increasing.

In April, 1935, Grant left Iowa City for his first one-man show in New York—a high point in his career. At the Ferargil Galleries, according to a report in the New York *Herald-Tribune,* Grant showed up a fortnight late, and in a cubby-hole off the galleries' exhibition room, "the 43-year-old chubby, roly-poly painter unburdened himself." Grant's subject at the Ferargil was regional art:

Too many fellows are trying to climb on the band wagon of regional art . . . They are mistaking the superficial mannerisms of Johnnie Curry, Tom Benton, and myself as the real thing, and painting in these manners. While I am trying hard to get rid of those early mannerisms which *they* think are so essential to a style.

I am just collaborating on a book . . . art can become a dynamic, significant form of expression, understandable to everyone, virtually, and not violate aesthetic principles . . . art need not be the exclusive property of the intelligentsia as so many surrealists and post-impressionists seem to think. They are very bitter about our work. It, too, in time, may become old-hat, but I hope I shall never be known to become bitter about our work, a Bitter Old Artist! I shall quit painting first.

Grant did not live long enough, but I doubt that he would have quit painting under *any* circumstances. He probably would have satirized himself with a grin. Yet, later, he became very upset, and wanted to "begin all over again" and "in a new place."

One reviewer reported that, in the New York showing, *Daughters of Revolution* was hung somewhere behind a door, as if "in shame." If the painting were there, and raising the critical dust, it would seem more natural that a gallery make the most of that publicity and discussion, and give it a prominent place for all to see. Except—among the vicious criticisms of *Daughters*—was a question of the painter's loyalty to his country!

A letter from the Ferargil to David Turner, thanking him for the loan of so many of the paintings in his collection, called the show "a phenomenal success from start to finish" and "the talk of the town." The letter further stated that more than 16,000 persons visited the exhibition in just three weeks—a record attendance.

Stone City, Woman with Plant, local scenes, Italian scenes, and the Shaffer portraits were exhibited at the Walker Galleries in New York in November, 1935. At the same time, the galleries announced they would continue to handle the work of Wood, Benton, Curry, Doris Lee, Barnett Aitkin, and David McCosh, and other American artists for whom they were already sole agents.

When Grant returned to New York, the cry went out, "Grant is back." Christopher Morley entertained famous New Yorkers in his honor, and Morley presented him with a copy of *Onward Ho*. "This," he said, "is for Grant Wood, and so am I."

88

Grant was the special guest at a dinner given at the Sherlock Holmes Club Restaurant, where the party guests wore visored caps, dinner was served from old-fashioned square pianos, and the guests worked Sherlock crossword puzzles later, in "secret chambers."

After this trip the Society for the Prevention of Cruelty to Speakers, the S.P.C.S., was founded in Iowa City with Grant's help. An auxiliary of the Times Club, which brought noted persons to the campus to speak to its members, the S.P.C.S. had rooms over Smith's Cafe. Here, visiting speakers could relax instead of attending teas and dinners. The rooms had a strong Victorian flavor—cabbage rose wallpaper, a stuffed canary under glass, and a motto for the wall, "No Place Like Home." There were blue plush chairs with horn arms, and heavy lamps with prisms overhead.

Tom Benton was the first to enjoy this period seclusion. After his lecture members accompanied him to the refuge, where Tom played "Frankie and Johnnie" on the harmonica and Grant did a clog dance he had learned long ago from Paul Hansen. Other famous visitors to the club rooms were W. C. Handy, Stephen Vincent Benét, Thomas Duncan, Sterling North, Nicholas Roosevelt, Christopher Morley, Thomas Craven, and McKinlay Kantor. John Curry, while visiting this club, made a sketch of Grant—later it became a finished portrait. Dorothy Pownall of Iowa City reported the Benton lecture which was the occasion for the opening of the clubrooms:

> This man, Tom Benton, of Neosho, Missouri and New York talked about art to these people. He introduced his friend, Grant Wood, who like himself, is interpreting the American scene on canvas in language that people can understand. The lecture was erudite but the speaker was chummy and his tie just enough askew to make him entirely approachable. . . . No backslappers are these modern artists. . . .

The reporter also reprinted in her article the letters sent by Grant Wood and Tom Benton to the Times Club before the meeting. Grant Wood wrote:

> As you know, I am modest to the point of being frail and therefore look to you to see that I am not embarrassed by excessive praise, no

89

matter how true it may be. If you feel obliged to mention something about it, it might not be out of place to point out the well-established fact that *American Gothic* is THE outstanding American painting today.

On second thought, perhaps this is too strong. *Dinner for Threshers* is also a superb painting. As for Thomas Benton's paintings, you should bring out that he has a beautiful wife and comes from Missouri.

Thomas Benton wrote with equal modesty:

I should tip you off that America's most celebrated examples of rural painting were, by a strange coincidence, painted by me. My murals in the Whitney Museum of Modern Art are simply staggering. My murals in the Indians' Building at the World's Fair were knockouts. This is the straight stuff. As for Grant Wood, I refer you to *Time* magazine in which I am quoted as saying: "I know an ass and dust of his kicking when I come across it!"

One of Grant's lecture trips was to California. The press there big-lettered him, "The Bible Belt Booster," and said that Grant looked more like a small-town banker than the glamour boy of painters. Arthur Millier, art critic of the Los Angeles *Times,* in a long visit with Grant on that trip, asked him if he were not in fact the Man Who Discovered Iowa. Grant answered, "I didn't really discover Iowa; that's too broad a proposition for a fellow like me. But I rediscovered it *for myself* when I returned from my third trip to Europe. America has found a type of painting all its own. We have finally broken away from Europe and found, discovered, our own way of expression."

From time to time during these years, word drifted back to Cedar Rapids that there was friction developing between Grant and Sara. Personal friends of Mary's and mine in Iowa City spoke enthusiastically about Grant's beautiful wife and their beautiful home and exquisite entertaining. But, they added, "We think Mrs. Wood rather likes to shock people. Being an artist herself—as she often reminds us—she is bound to be an exhibitionist, but the grown women of Iowa City are not yet wearing pants on the downtown streets."

Hometown people, with a few exceptions, were ignored by Sara. The exceptions included Bruce and Ruth McKay, Fan

90

Prescott and her friend Dr. Florence Johnston, Herbert and Billie Stamats, and of course, Winnifred and Marvin Cone, who went often to Iowa City to visit Grant. Paul Engle, a very old friend of Grant's from Cedar Rapids, was bound to be acceptable; he was on the faculty at the university, and the Engles were among the "new friends" Sara entertained.

Billie Stamats remembers when she and Herbert were invited to what they took to be an informal, picnic-type party, and dressed in warm, informal clothes for an outdoor possibility. They arrived to find the Iowa City guests had been invited to something quite different, for they were all elegantly dressed for a formal dinner.

Bruce McKay often spoke to Mary and me about his strong feeling that Grant was "clinging" to his old friends from home. Bruce wrote of his contacts with Grant during his married life in Iowa City:

During his work on his home in Iowa City, I made several trips to assist Grant and his wife make structural changes on the old house.

At times he seemed to be awed by all the publicity, and his married life. His wife always welcomed me as one of Grant's old friends and associates, and after their marriage, Grant was much more restrained. I always felt that the breaking away from his lifelong friends in Cedar Rapids was a battle forever going on within himself between his old loyalties and his new life.

But in all justice, it seemed that at times in his new life, he was happy. On two occasions my wife and I were overnight guests in his home. It was January and very cold. I had developed a bad cold, but as the fall before I had been forced to refuse an invitation, we decided we should go anyway. After the drive through the Iowa hills to Iowa City, we arrived, cold and hungry. We were greeted by Grant himself, lovable warmth beaming from that pink round face under the pink mop of hair. He greeted my wife Ruth first, holding out both his hands. He always liked Ruth. He made us both so welcome.

Sara, his wife, came in, for since they had no maid at that time, she was getting supper. A tray of martinis was passed around. As was his habit, Grant teetered back and forth before the fireplace, beaming.

"How is everyone in Cedar *Crick?*" asked Sara, sarcastically. Grant looked a bit pained, but we did laugh that off for we thought it a bit funny. After the drink we went to the dining room where they showed us the rock china, a gift from William Allen White. They were very proud of it.

Mrs. Wood's son by another marriage and a dental instructor at the university then came in with his wife and two-year-old daughter.

91

He was a tall, studious young man, his wife was dark and attractive and appeared to be competent, and a generally nice person. Grant had told me before how much he was attached to both of them. However, it was to the child that Grant was devoted. He told me how fine it was to be a grandfather. The child came to him at once as if it was the natural thing, and I have now forgotten the child's name, but I have often thought what a wrench that must have been, that parting, after the breaking up of their home. . . . At dinner we had roast veal flavored with a little garlic, cooked in an electric roaster. Sara was a good cook and as a hostess always made us welcome. After dinner we talked until ten, Grant about his lecture tours and painting, Sara about her personal feelings about people. At times she would go too far and Grant would quietly say, "Sara, I don't think that's right."

By bed time I was coughing my head off. Sara brought in neck rub, nose drops, and all the rest of the cold remedies. After complete application, I slept well and woke up better in the morning. The next day, the Woods had some university friends in to a fine chicken dinner. We enjoyed the weekend thoroughly and really, Grant seemed very happy. A period of happiness is something to be cherished in this life even though it passes.

In 1935, we built a small house ourselves. We had gone through tough times and still fearful the house was too small and more or less a small, standard cottage. Nice, but nothing special to comment on. We built it on a rather large lot with good trees. From time to time Grant drove over to look it over, but had little to say. He watched me put in a mantle with a shelf (that *I* like) and still said but little. In time the house was finished and one sunny afternoon, to save expense, my wife and I were washing the windows ourselves, outside, on the stepladders.

Grant and Sara drove up the drive with Thomas Craven, the author on art. I had never heard of Mr. Craven at that time, who was dressed in an old felt hat, rough shirt and corduroy pants. However, even in such a disguise, he didn't look the part of a backwoods countryman.

They got out of the car and Grant was trying in his nice way to say something about the house that was unusual. On each side of the entrance were two small pilasters. At the top, between the necking and the capital, the flat space had been filled in with small oval plaques, sawed out rather unevenly by one of our carpenters. They caught Grant's eye, and pointing to them, Grant said, "How I like those; they show they are made by hand. Takes away that hard, machine look."

We went inside the house, bare of furniture. There seemed little to show them or talk about. The bookcases to the rear of the living room and on each side of a large window were of low design, only about four feet high, when I knew that Grant felt bookcases should reach the ceiling, in that way becoming part of the wall. I really

felt as if I should apologize for the height of the mantle and the bookcases, but I kept silent. So did Grant. They were all on their way to their cottage at Waubeek and Sara had some soft drinks in the car. She brought some in and we sat on the bare stairway drinking out of bottles and talking. Thomas had been looking over some plans and drawings, and he pleased me when he told me of the designs he had especially liked, that he thought them excellent.

Reports of friction over money matters and a frequent clash of personalities between Grant and Sara continued to waft back to Cedar Rapids. During a quarrel one evening, Sara left the dinner table and went upstairs, and Grant went out to mow the lawn. Sherman, Sara's son, came down to tell Grant that Sara was ill. Grant, not pausing in the mowing, told him to order an ambulance and have her taken to the hospital. When the ambulance arrived and took Sara off, Grant did not stop mowing.

While Sara was in the hospital, Grant went to Clear Lake and worked at painting *Spring in the Country* in a little studio he had fixed up out of the old, derelict railroad depot. Busy with teaching and many other things, he had done very little painting in the last two years. Grant himself said, "Since painting *Death on the Ridge Road,* I have done no painting . . . for my time has gone into this new book and into the plans for the ten-year project under which the students at the university and I will decorate with true fresco a Dramatic School that has just been built here at the university."

The students were enthusiastically "with" Grant during this time and with these plans. He was no *lecturer;* he worked beside them in his overalls; he was with them, always urging them to *express themselves.* Always full of ideas, he was tremendously good company, and they liked him. Grant was delighted, of course, with the "epidemic" of calls for murals for post offices in Iowa, and so proud that in competition with professionals, so many of the Iowa students had received commissions for them. "A work which does not make contact with the public, is lost!"

Another reason for "no painting" was his insistent desire to get on with the book he wanted to write, *Return From Bohemia,* which already had had several false starts and which had taken the place of at least a year's painting, he admitted. It concerned his life in Paris and his return to Iowa and was an enlargement of the statements he had already made so many times about his new

attitude and about those fine ideas he got "when milking a cow."

Park Rinard, Grant's secretary, was helping, too. The idea of the book was summed up by Grant's statement: "French painting is very fine for the French people but not necessarily for us. And I started out to analyze what I really know. And it was Iowa."

When he was painting again, at Clear Lake, he told Dean George Stoddard in Iowa City that he wanted Sara gone before he returned home. And Sara left in her new Chevrolet. On September 27, 1939, the Des Moines *Register* headlined the divorce. Sara was allowed her own name, Sara Sherman, and awarded $5,117, to be paid in installments of $175 a month. Along with the divorce came the discovery that Grant had neglected to pay his income taxes for a few years. There had been no Fan, no Dave, to remind him.

Although Grant had told friends that he felt free again, ready to take on the world, and was planning a lot of painting, his personal unhappiness was added to by trouble at the university, where he was the subject of great personal animosity of other members of the faculty who scorned the Public Works of Art Project (P.W.A.P.) and hooted at the idea of murals for schools and public buildings and who resented his great popularity with his students. Tom Benton was furious about this and called it jealousy of a man who had no row of academic degrees, no swinging key, but who had instead the affectionate enthusiasm and loyalty of his students.

With this controversy going on, Grant was neither well nor happy. His doctor tried to cool him off by prescribing rest and exercise. And he began carving stone with a concentration and determination seen in people who are "working off a mad."

Grant had been interested in lithography for years, but in 1937 he went at it seriously. Then, he literally dug into the stone as if his life—and his peace of mind—depended on it.

During this period, when Grant was under contract to the Associated American Artists, he did one lithograph which was not allowed through the mails because it was, censors said, "pornographic." He had chosen to picture how a farmer, hot and dirty from his chores, with no bathtub, took a pail down to the horse trough, where the sun would have taken the chill off the water,

94

and scooped up water to drench himself. Grant made the mistake of picturing him naked, front-to. Grant's reaction was: "About as pornographic as a statue of Apollo!" But he withdrew it, not wanting to make a "cause" of it.

In 1936, Grant Wood, the boy who walked in and out of the university without paying tuition or getting credit or degree, received his first honorary degree. He became a Doctor of Letters at the University of Wisconsin. Later, he was awarded a Master of Arts at Wesleyan University, a Doctor of Fine Arts at Lawrence College, and a Doctor of Fine Arts at Northwestern University His amusement at the first of these shows up in *Honorary Degree,* a lithograph which happens to be a favorite with many of his hometown friends. As Dr. McKeeby said, there he is, tubby, grinning, stubby toes of his shoes peeking out from under the long gown. It has been dubbed, "Scholastic Gothic," and we agree with the feeling expressed widely that he is saying to us, "Look who's here!" In *Honorary Degree,* I find it fascinating that every line and curve fits into a pattern of design, there is not a pen stroke that does not do so, and that every assisting professor in the lithograph was someone Grant knew in Iowa City. Grant had a predeliction for live models and an inability to make them unrecognizable.

Fertility is one of my favorite lithographs. Riding through the Midwest, you can see that the animals and the crops have the big, roomy buildings, and a little one-room house was built out of what was left. *Fertility* portrays this, with that characteristic sense of humor. Here is the bulging barn with the edge of the cornfield, taking up practically all the picture, and off at the side, almost to escape notice, the farmhouse. That is one meaning of *Fertility,* but to me it meant something more. Iowa has been referred to as a "pregnant land," and as I ride through the state, or look at Grant's paintings of it, I sense the fertility in the rolling hills, the rich fields, the bulging crop rows. The land is full of future life; so to me, fertility has this meaning, too. In the shop, the lithograph was referred to as "Hazel's Pregnant Barn." *Young Corn, Spring Ploughing,* and *Fall Ploughing* have this same rich and productive implication.

Grant hunted a long time to find the famous red flannel underwear he portrayed in *Midnight Alarm.* Finally he put an advertisement in a newspaper, and four suits turned up as well as

a fanfare of publicity. In *Midnight Alarm* Grant pictured a young man in the long suit of underwear coming cautiously down the stairs, an oil lamp held over his head.

For only three years out of his fifty, Grant was a Mason. Sympathy and satire are both found in his lithograph, *Shrine Quartet*—the pyramids in the background, duskily, and the four faces raised in song—that uncanny ability to catch the spirit of the thing he was doing.

An illustration entitled *Family Doctor,* later a lithograph, was commissioned by Abbott Laboratories. Reproduced many times, it hangs in hundreds of doctors' offices even today. Grant said of it: "Let this be a tribute to the skill and artistry of the Family Doctor from one who for many years has known him well, sometimes in his professional role, occasionally as a critic, always as a friend." This lithograph was one of the last things Grant did before he died.

We bought for sale in our shop the lithographs, and the color reproductions of Grant's paintings, as soon as they were on the market. They were available from the Associated American Artists and from New York Graphic Company. The first lithographs sold at retail for five dollars. When we went out of business, we sold our "collection" to the Guaranty Bank, where they now hang. We were paid twenty-five dollars for each of them. The last lithograph to be available, advertised in the Associated American Artists catalogue in the late 1960s, was listed at seventy dollars. Now out of print, the best collection of them in Cedar Rapids is in the Robert Armstrong home.

Grant also did a great deal of illustrating while he was living in Iowa City. Madeliene Darrage Horn, wife of Professor Horn of the University of Iowa, wrote the book, *Farm on the Hill,* which Grant illustrated in 1936. Illustrations for this book included: an old man in overalls and dark dotted shirt, sitting on a stump and eating out of a bucket; *Saturday Night,* showing the bare *back* of a boy in a wooden bathtub; a woman paring apples; pets on the farm; and others. They were considered good enough for exhibiting by the Walker Galleries in New York, who put *Saturday Night* on the cover of the exhibit folder. And inside the folder, the commentary said:

These illustrations are unquestionably the best in that field . . . Wood gives to his characterizations of farm life the larger scope of

decoration and sculpturesque design which, together with his supreme craftsmanship, sly personal humor, understanding and affectionate observation, make them little masterpieces of his art. . . . Rare items for the collector in their own right, they constitute a uniquely handsome series of decoration. Frankly designed to delight, they should reach the hearts of connoisseurs as well as of children for whom they were originally intended.

The book jacket Grant designed for Sterling North's *Plowing on Sunday* shows a farmer drinking from a jug held typically on the arm. The farmer is in overalls with bib and straps, very much like the Wood "painting costume." Grant had also been very anxious to illustrate the Limited Editions Club edition of *Main Street*. He did, and it was considered a fine job. He did many illustrations for religious and business publications, newspapers, and magazines, including covers for *Saturday Evening Post* and *Saturday Review of Literature*.

To say in truth that Grant did no more painting after *Death on the Ridge Road* is only a small wedge of the truth; he never stopped doing *something*. His mind and hands were busy on several levels of "an idea." He was a people's artist, as he intended to be, and he spoke simply to people who had no difficulty understanding him.

Bruce McKay, who knew him so well, once said to us that Grant was like an earthbound native away off in a foreign land. He never could pull up all his roots.

Bruce wrote of a visit with Grant following the period of painting in Clear Lake:

Grant invited us all down to Iowa City to dinner. The younger son is the athlete of the family and at that strongly disapproves of all drinking. My older son's ideas are much broader. As usual, the grownups had some drinks. I should say everyone but me for I was battling a stomach upset at that time. Dinner was served on the long table on the porch where everyone faced the garden view.

The boys were both very quiet but acutely attentive for Grant had become a great man. They had seen his picture and paintings reproduced in *Time, Life, Saturday Evening Post,* and other magazines.

Eric Knight, the author, was then living in an apartment in Grant's home but for the day was out of town. During the meal Grant talked but little about his painting. His enthusiasm was on an old

97

depot at Clear Lake he had fixed up into a studio and the ideas he had about fixing up the old barn in the rear of the house. Casual visitors were bothering him and to get away he had a studio in an old building downtown. Out in his yard he had some old shutters fastened together to form a protection from prying eyes as he took his sun baths, but even so, at times, the curious looked over the top to gaze upon his reclining figure.

After dinner he demonstrated his health-building equipment, then played his records of cowboy songs, or folk tunes. I'm not sure which. Then we had another drink.

Later he took us down to his studio to show us his last two paintings, *Spring in the Country* and *Spring in Town*. He had all of the old enthusiasm of ten years before when he first showed me his work on *American Gothic*. He told us that he could now paint again.

He wanted us to go to his favorite place for a hamburger and coffee. It was a tiny place with about ten stools. The waiter treated Grant as an old friend. They were good hamburgers, set between round, flat buns, just like the ones he used to take on our old picnics. We drove back to his house. I don't remember that any of us said anything on the way back. It was a beautiful summer evening. We could see figures in the lighted living room. He thought that Eric Knight and Park Rinard were back and wanted us to come in, but we said goodbye and drove away. For some reason we were all quiet. Finally my younger thoughtfully remarked, "He certainly is a good guy!"

Of another visit with Grant, Bruce wrote:

The last time Grant Wood visited our home was in June of 1941. Park Rinard and Grant stopped in on a beautiful summer evening. Grant said he was staying for just a few minutes while Park went on an errand. It seemed just like old times. The boys were there, now sixteen and nineteen years of age. After a time Park returned and we all talked and laughed. Grant was in perfect form. He had just returned from a trip to Key West and he wanted to go back there sometime. At about ten, the boys went to bed. Park kept suggesting that they leave for Iowa City as Grant had an important meeting in the morning concerning his status at the University.

Park seemed worried as to its outcome, but it was all of little concern to Grant. They stayed until 2 A.M. before Grant was ready to depart. They walked toward the road where they had parked their car, and I watched his compact little figure with pink hair disappearing among the trees and bushes.

In the summer of 1941, Grant wrote two letters to John Reid, in which he said:

98

For some time I have been intending to write you and tell you how much I appreciate all that you have done for me in the past two months. But my feelings in this matter are too deep to translate into words, and I can only hope and believe that you know what is in my heart. . . . This has been a magnificent summer for me—the best in many, many years. And despite what you say, the peace of mind I am enjoying is due in very great part to your accomplishments in my behalf.

Grant entered the hospital in Iowa City the following December. He never came home again.

Final Days

At first Grant's condition was reported to be due to overwork. He underwent major surgery on December 19. He had cancer of the liver, and he never left the hospital, where he died on February 13, 1942.

"We lost Grant Wood," said the janitor at his studio.

"We, the people, lost Grant," said Park Rinard, his secretary.

The services were held in the Turner Mortuary in Cedar Rapids, amid all his paintings. Dr. Willard Lampe of the University of Iowa School of Religion said at the service, "Grant had the vision to come back to live in his own country and immortalize it for us all, make us see its richness and generosity to man. He possessed the creative art to put it on canvas for us, to enrich our lives and those that will follow us."

Friends from afar, friends from his boyhood, from Iowa City, stood bareheaded as he was laid to rest beside his mother in the rolling Riverside Cemetery, overlooking the Wapsipinicon River near Anamosa, where he was born.

His sister, Nan Wood Graham, and Park Rinard, whom Grant had named his official biographer, were named executors of his estate. His assets: $29,159.

People who had known Grant were asked what they remembered most about him, and David Turner was the personal recipient of a deluge of mail. Notices, news articles, and letters telling anecdotes long forgotten, from people barely remembered were received by Dave. Marvin Cone was, of course, one of the first to be asked about his friend, Grant Wood. "What did you think of him?" was the typical reporter's question. And Marvin answered:

We never discussed politics, but he was a great believer in democracy. He liked people, common people—loved to talk to them anywhere,

everywhere. He detested insincerity. But he and I had too many technical problems about painting to have time to discuss politics. His unfailing cheerfulness and good humor always impressed me. He always enjoyed a joke on himself. I guess you know that once, just for fun, we painted portraits of each other. Grant was Iowa's greatest artist, but he never took himself too seriously.

Marvin was also often called upon to speak, as he does here, of their early days, the trips to Europe, and Grant's decision to come home to paint the things he knew intimately:

The portrait of his mother and *American Gothic* do mark the changed manner of his painting. The Art Association is very fortunate to own *Woman with Plant*. No end of patience, infinite pains, the ability to keep his enthusiasm at a high pitch, working often until four o'clock in the morning, and his unusual physical enjoyment in that kind of experience, putting paint on canvas. He was not a temperamental painter, not at all. Sensitive, conscientious, persistent and honest—satisfied with nothing but his best. No, not temperamental as I think you mean it. Most decidedly his painting has caused a trend in American art. The best testimony as to how his home folks liked him is the widespread ownership of his work in this community, not only in homes, but in offices and in industry.

Marvin also mentioned the up-coming Memorial Exhibit to be held of Grant's work at the Art Institute in Chicago. "This," he pointed out, "is a most unusual kind of affair in their program, never heard of before! This fact alone should answer many questions the world has about him."

For Marvin, as an artist, there would never be another person in the world quite like Grant Wood, and his great sorrow at Grant's death are revealed in this simple statement:

His passing removes a great figure from American art. Vitality, craftsmanship of a high order, and a flavor particularly American, were his. He was always a consistent encourager of young artists. Some of the happiest memories of my life are associated with Grant. . . . His qualities of heart and mind were unique and distinguished. His death at this time is a great tragedy.

In the spring of 1941, Grant had gone down to see Tom Benton in his Kansas City home, to talk about work he had in mind—some historical subjects—and new and faster methods of

execution. Benton in an article for the University of Kansas Press after Grant's death wrote of that visit:

At home where he had been mixed up in university politics, faculty politics, he had been through an ugly winter of small bickering with small people and although he had won out, that business had left its mark. Grant suffered over trivialities. But there was strength in him and a drive for work. . . . "Tommy," he said to me, "I think you may see something really good come out of me in the next few years."

I next saw him in the hospital in Iowa City, skinny and yellow with the color of death. He winked at me when I came in, he pretended he was interested in getting back to painting, but he knew that he was dying. I didn't stay long because he was too weak to talk much. He died, of course, without having any time, without having a chance to begin working on what he had envisioned and talked about.

Grant was a simple man. Others less simple could never understand why he was famous. . . . People who were wise in other ways choked before the acclaim given to this obviously middle western character who was so slow of speech and so devoid of the usual "paraphernalia and sophistication." Some of these are still choking. It is so hard for people who *think* about things to comprehend the significance of people who *do* things.

Thomas Hart Benton was the only one of the three—Benton, Curry, and Wood—who was so eloquently and articulately bitter about the treatment of the common man who paints by the "highbrows"—critics and people who consider themselves a special breed. He resented this treatment for all of them.

John Steuart Curry spoke of Grant in a calmer mood:

Grant, more than any artist of our time, did more to awaken in the public minds of American people an interest in American painting . . . he taught young painters that in their environment was a wealth of material to interpret. For Grant changed the idea that people had to go to Europe to paint, or to Gloucester, or to Newport. He jarred America awake to the endless glories of American landscapes. Life. People.

Adeline Taylor, who more often than not was assigned to cover Grant for the *Gazette* through these years, collected the following statements from his friends with whom she talked:

He had a green thumb. He loved to garden.

102

It is very appropriate that the *Saturday Evening Post* put *Spring in Town* on its full-page cover.

Up on Fourteenth Street, after the Woods moved to Cedar Rapids, he had his own garden and cultivated it.

The young man who is working the soil in *Spring in Town* was modeled by George Devine, son of the famous football coach, Glenn Devine. George was a senior then at the University of Iowa, and how he liked Grant!

The panties showing on the little girl reaching for a flower from the tree, came from the time Grant saw a little girl, one hand clutching a bag of candy, the other reaching up to her mother's hand as she walked away, the bit of panties showing. He noticed so many things, and never forgot!

He didn't miss the ordinary things that went on around him, like rug-beating, lawn mowing, roof mending, hoisting hay into the loft of a barn, often trivial things, seemingly un-noteworthy, hardly the "heroic material" he spoke of for painting. I think it was that "commonness" about him which made us more than respect him, love him!

He was so ordinary, so common. He never forgot to speak to you if he once knew you, or met you or saw you. I read in the paper that even when he couldn't talk French, he made friends with everyone in France. How like him!

The *Daily Iowan,* student newspaper, and the *Iowa Press Citizen,* area newspaper, did Grant honor by simply filling their pages with reproductions of his paintings. And on every hand in Iowa City, notices of his death were to be seen in black letters at least two inches high. Dean Stoddard of the University of Iowa said, "He painted what he loved, what he knew, and sometimes a little fun. Grant had lots of fun, hours of it, with Marvin Cone and their painter friends, jocular, jeering, howling, insulting—delightful." And Thomas Craven, the critic, predicted, "Wood's work will influence painters for a long time to come."
Time magazine, on February 21, 1942, pictured Grant at 5 Turner Alley with *American Gothic* on the easel behind him, and reviewed the facts of Grant's final years:

an unhappy marriage in 1935 that ended in divorce four years later, and the faculty row in Iowa City . . . spewed up some ridiculous

assertions that Grant Wood copied his paintings from photographs. Hypersensitive Wood scarcely bothered to refute the rumors.

More than any other painter in the United States he expressed the unabashed simplicity and dignified realism that lay behind the complacent, materialistic exterior of rural midwestern life. Other painters may see, and paint again, the plain, practical beauty of the Iowa landscape. But Grant Wood discovered it.

The controversy about Grant Wood, which in his lifetime had run mildly in his home community and his state, was waged bitterly outside these boundaries in the 1930s—the days of his eminence in painting, the days of his most controversial paintings—and raged on at his death and grew more heated at the time of the Memorial Exhibit at the Chicago Art Institute in the fall of 1942.

The trustees of the Art Institute had passed a special ruling, for the first time, to feature the work of one artist in their fifty-third annual exhibition of American artists. With the invitations that went out announcing the exhibit was a separate engraved card for the special memorial service for Grant Wood.

Daniel Cotton Rich, director of fine arts at the Art Institute, wrote to David Turner:

Grant Wood was an art pioneer in his own discovery of America and in his influence on American art. His pictures are selling for as high as $10,000 each. Famous collectors are lending their paintings for this Exhibition . . . it seems to the officials appropriate at this place and at this time. For Grant Wood was a student of our school, and since *American Gothic*—which helped to make his reputation—was purchased by us in 1930, is *here*, we want very much to do him honor.

Mr. Rich asked David Turner for the privilege of the loan of *The Fountain of the Observatore, Paris, Old Shoes,* and *John B. Turner.* In addition to the paintings, he requested photographs of Grant's Memorial Window and the Turner Alley Studio with its famous door and clock as well as the photograph which pictured Grant standing before *The Midnight Ride of Paul Revere.*

Many Cedar Rapids people were personally invited to attend the opening of the exhibition. Nan Wood Graham was photographed there, standing in front of Grant's painting of her.

104

Marvin and Winnifred Cone were pictured with Charles Worcester, honorary president of the Art Institute, and Mr. Rich. Marvin's *Davis' Dummy* was included in the exhibit. David Turner was there as were John Curry and Park Rinard. *Woman with Plant* was reproduced for the cover of the program for the exhibit. Inside, Park Rinard, who also had attended the opening of the exhibition, had written:

Through paintings, Grant Wood speaks to the people as few artists have in our time. His was a people's art and so he intended it to be. . . . His regionalism was not a narrow aesthetic design or a Chauvanistic slogan. It was simply the common sense of the creative mind of the man, the reiteration of an old truth.

The reaction of "common people" to the exhibit was tremendous: appreciation, affection, and defense from those who had read the harsh criticisms in the Chicago papers, particularly from Dorothy Odenheimer, who recalled that Grant Wood was said to be simple, natural, wholesome; however, she said:

This doesn't change the fact that he was a *provincial,* whose vision was restricted in more than physical sense in the rolling hills of Iowa. He has no taste, no feeling for color, no texture. For a man who lived so close to the soil, his landscapes are remarkable by their coldness, no atmosphere, no smell of the soil, no wind in the air. These paintings are manufactured to a pattern which soon grows tiresome by repetition. Forty-eight examples [in the Memorial Exhibit] oppressed by their coldness.
 Wood's art is hard and frigid, his approach literal and photographic, you will see how dangerously near his "Woman . . ." is like his mother! Even in his early Paris days, Wood's diluted attempt at impressionism, or pointillism, was dull, mediocre and undistinguished. . . . There are hundreds of artists in Chicago who better deserve a Gallery Show, but Grant Wood occupies "the parlor," successful in death as he was in life, and for the same reasons.

Another Chicago critic, Fritzi Eisenborn, wrote:

Wood's success was due to his being a product of isolationism, his isolationist trend of thought and action rather than his ability as an artist, and contributed nothing. It's a trend of escape thought and action which was popular with some groups yesterday and which is definitely obsolete today. All one sees as he enters the gallery of honor is a yellow, greenish haze. There is hardly a degree of value variation

from one end to the other. Grant Wood was without imagination, inventiveness, or inspiration. The covers of *New Yorker* magazine are preferable.

A conservative Chicago art writer, Evelyn Marie Stuart, hit back, saying:

Mrs. Eisenborn's hysterical outburst against Grant Wood, whom she apparently neither understands nor appreciates, comes as a cock-eyed policy in art criticisms. Anyone who reads her stuff should know that *ideas in painting* are anathema to her, especially when projected through clear statement in representation. She is the protagonist of the bilious, the bleated, the bleary, the distorted, confused and delirious, masquerading as fanciful, the meaningless and turgid, posing as profound.

Grant Wood, although no luscious colorist, is something of an American Hogarth, a satirist of the old original Yankee stock, of the rural districts whose traditions are rooted in our history, and whose appeal to the public is still very strong.

It is this, and not museum patronage, which accounts for his generous and tremendous popularity . . . Grant Wood is very "Ioway" today, and American, always.

C. J. Bulliet, art critic for the Chicago *Daily News,* was one of the first to praise Grant in 1930. The "new" Bulliet, at the time of Grant's death and the Memorial Exhibit, gave himself credit for starting the vogue for Grant Wood pictures, foreswore his earlier praise and lamented, sadly, that Wood had an "adroit" talent, a shrewd sense of showmanship, and a sort of political demagogery—small-souled. Grant Wood, he said, was one of his "most grievous errors, an error of some twenty years of art criticism. Nothing of the promise of *American Gothic* has been fulfilled. It is still Wood's masterpiece but not worthy of making a painter ranked 'great.' The Memorial Show serves only to point up Wood's weaknesses instead of his small merits."

Tom Benton and Aaron Bohred responded vigorously to "the defamations of the Chicago set of critics who are doing a distasteful dance macabre over the still warm grave of the creator of *American Gothic* and *Dinner For Threshers.*" And Payton Boswell, writing in the New York *Times,* said:

Because the United States is more international-minded today, Grant Wood with all those with him in a long crusade for a genuine native

106

expression in the arts are in the eclipse, today. Flag-waving has become something of a felony. Art is wedded to the social and political events of its time and today is not the time for Grant Wood and his rugged nationalism.

Because Grant Wood committed the grievous sin of stressing subject and promoting regionalism, he felt during his last years the full wrath of the international ivory-towerists. To them he was only a "graphic" artist; to others he was a gifted and sincere painter. It is still too early to make a reliable estimate of his stature among his contemporaries.

Dorothy Doughty in the Cedar Rapids *Gazette* spoke for many people of the community when she differed with Fritzi Eisenborn:

Grant Wood an isolationist? He was an anti-appeaser from the start! In 1939 he painted a poster for British War Relief; later he *refused* to do one for America First. Fritzi Eisenborn says art is international in intent and content as she slays the museums, galleries and magazines which climbed on the band-wagon of isolationism. . . . Happily, Miss Eisenborn, artists do not work in an international vacuum; they interpret the life they know, and their interpretation reflects their nationality. Goya, Vermeer—all through the European scene. Only in that sense does art become international. . . .

You hang "isolationism" over *Daughters of Revolution* and this is funny because it is a painting which, in rare Wood humor, pokes fun at that very thing. Unimaginative? Uninventive? Uninspired?

You find him insensitive to "form, shape and color." Have you seen *Spring in Town* and *Spring in the Country?* Your contemporaries in the critical field have said just the opposite about these paintings. And they, too, were *good enough* in color to reproduce well. When he was finishing *Spring in the Country* at his studio at Clear Lake, Iowa, he called a Danish farmer over to see it. "By golly," said the farmer, "you can see the shadows under the cow!"

The people of his home community also honored Grant with memorials. On July 20, 1947, the diamond jubilee of the little Antioch School, where he had been a pupil, honored Grant Wood. The school is five miles from Anamosa, where Grant was born, and the occasion was a typical country event, with throngs of former pupils, teachers, and friends, many of whom came a considerable distance to be there. Iowans will know what the scene must have been like—the tables outside on a summer Sunday in the country.

The committee in charge was David Turner, Marvin Cone,

and Malinda Nielsen of the school. Dave took some of his original Wood paintings to be shown in the school house. Frank Wood, Grant's brother, gave the lithograph *Tree Planting* to the school. A small replica of the school, perfect in every detail, had been made by Mae Amelia Zeuch. Music was by the Anamosa High School band, and a tableau representing Grant's *Tree Planting* was presented.

Featured speaker was Fan Prescott, who said, "His life is the story of a man who loved life with a passion no less intense because it was deeply reserved." Fan recalled here the story about Grant asking Mr. Hood, the chief engineer at McKinley School, if he would allow Grant to use his shower. Mr. Hood had evidently agreed to accommodate Grant, for he later called Miss Prescott down to the boiler room and said, "Look!" The half-door of the shower had been painted green, with daisies and butterflies all over it, and the lettering over the top read: HOOD AND WOOD. Reading about it all again, after all these years, and talking to Fan, I have often thought to myself, "If Grant is painting somewhere in another world, he is at this moment working on *Reunion at Antioch.*"

McKinley School dedicated The Grant Wood Room on December 4, 1947. In 1951, two Wood lithographs, *January* and *February*, were given to the school by Nan Wood Graham and Frank Wood. *January* is a field of cornshocks in winter, snow blown, rabbit tracks leading up to one of them. *February* shows two horses, their heads bent to the winter wind, their manes flying back.

In 1951, a contest was held to select a name for a new school in Cedar Rapids. The winning entry was submitted by Tom Woodhouse, a fifth grade pupil at Buchanan School and the son of Dr. and Mrs. Keith Woodhouse. It was Grant Wood School. The school opened that fall and was dedicated in November with Tom, who was then a sixth-grade student at Grant Wood School, appearing on the program. Family and friends of Grant Wood who were present included Nan Wood Graham, Frank Wood, Marvin Cone, and Park Rinard. Fan Prescort spoke on Grant's educational philosophy, and Dave Turner gave recollections of Grant Wood.

Grant's works hang in many schools, business places, and homes in Cedar Rapids. Those who knew him as a boy growing

108

into a man had only compassion for the mistake of his marriage which was not so much an error as an outgrowth of the painter's life. But his home folk never ceased loving him, never censored him, and prayed that he would come back, which, to their great gratitude, he did. Then, he healed the seam between himself and David Turner.

His community as a unit expressed its sympathy, its love, and its loss.

Four years after Grant died, John Steuart Curry died. At that time, in an article reprinted in the *Gazette* from the University of Kansas *Press,* Tom Benton wrote:

Grant Wood is dead. John Curry is dead. They were closer to me in basic attitude of mind, in their social and aesthetic philosophies, than all other artists. Together, we stood for an art whose forms and meanings would have direct and easily comprehended relevance to the American culture of which we were by blood and daily life a part. . . .

It is not for me, left standing, to judge of our success as a whole. But I will risk this—whatever may be said of Grant Wood and me, it will surely be said of John Curry, that he was the most simple human being artist of his day. Maybe, in the end, that will make him the greatest.

Wood and Curry were oversensitive to criticism. They lacked the core of inner hardness so necessary to any kind of public adventure. Oversusceptibility is conveyed to others, and can be disastrous, and this was most emphatically so for Wood and Curry. Discouragement and annoyance were worked on them by their campus brothers . . . departmental highbrows pestered Wood from the beginning and they could never understand how a midwestern Iowan small-towner received attention while they, for all of their obvious superior endowments, received none at all. When we moved into the Forties both these men were in pretty bad shape—their good moments seemed to be short lived.

In their teaching they began to feel a scorn of the young, felt unwanted, unneeded . . . began to feel that their days were over.

Grant Wood, in the end, what with the worry over his latest debts and his artistic self-doubts, came to the strange idea of changing his identity. As far as I know, Grant Wood had no God to whom he could offer a soul with memories.

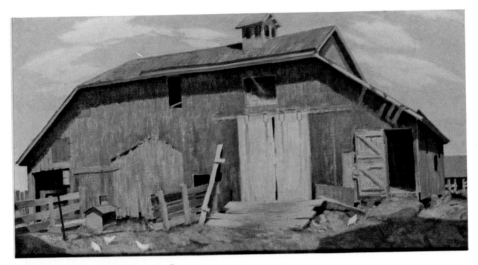

Old Iowa Barn, 1939, Marvin Cone
oil
Cedar Rapids Art Center

PART THREE
A
DISTINGUISHED
TRADITION
MARVIN CONE

The Teacher at Coe

Grant did "come home" to Cedar Rapids after his divorce. The occasion was the auction of Marvin Cone's paintings in 1939 following a sabbatical year away from teaching. David Turner and Will Boyd, representing the Art Association, had raised through the donations of some twelve citizens the sum of $4,800, or thereabouts, to finance a year of painting for Marvin.

At the end of the year, a gala affair was planned—an auction of the Cone paintings. Grant came home to honor his good friend with these words:

The paintings of Marvin Cone have a directness and honesty characteristic of the man himself. There is no compromising with problems of representation, no soft half-statement in his work. It is the full-bodied art of a man who loves the simplest qualities that meet the eye and depicts them with clarity and sound craftsmanship. . . . It is the mature work of a distinguished artist.

Grant stood there alone, speaking of his friend. There had been mixed reaction to Grant's divorce among his home friends— "I told you so" and "It had to happen" were common. But there was nevertheless a deep sympathy for this man who had learned that his old friends had been right and he had been wrong. We all suffered, to some extent, his agony.

Probably no one in the community had been more understanding or sympathetic about Grant and Sara than the Cones. They did not believe the marriage was a "good thing," really, but it was Grant's choice, and they were Grant's friends. Winnifred liked Sara, knew her many fine points and her abilities, and liked having her in her home, for any reason, but especially for Grant.

Marvin and Winnifred have said that the saddest thing about Grant's divorce was Grant's separation from Sara's small granddaughter. Grant was pathetically fond of the child, who loved him as much as she could a blood relative. Her childish companionship was very important to him, and the breaking of that tie was a very unhappy separation for Grant. Winnifred has often said, "Grant needed children. He should have had them. He had said he would probably never marry, for he had Nan and his mother. Children were very fond of Grant."

When Doris, the Cone's only child, grew up and was married, and brought her children home to the "little" yellow house on Fifth Avenue where Grant had spent so many happy hours, it was always in Winnifred's mind, as she entertained her family, that "Grant would have enjoyed them so much."

People in their minds often separate these two men—Grant, off on a collision course with fame, and Marvin, "just the instructor" at Coe—as now being apart, living totally different lives. Their lives *were* different. We know about Grant. And Marvin had his dedication to teaching and trod the more familiar path of the professor. Yet they were always close friends, seeing each other frequently. Grant liked Winnifred and she liked him, and she has told of the roaring good fun they had, the jokes they shared— even with young Doris—and the easy and complete understanding and affection between them. The necessary break in telling about these two gifted men seems to separate them. But it must be made clear that nothing ever really separated them, not even Sara.

Marvin was slighter, taller, much leaner, and longer of the face than Grant. His were the scholarly good looks of the intelligent, well-setup man. To me, he looked the aristocrat. But he bore himself without self-consciousness, and was always natural and at ease with people. In the portrait Grant did of him, *Malnutrition*, Marvin appeared gaunt. He painted himself as befuddled in *This Is How I Feel*. How did he look to the students on the Coe campus? "Like anything but an artist," said one. "Just like a very common, ordinary good guy," said another.

Marvin always seemed to seek anonymity. He seriously considered any artist first of all a person, a "common man." He once said that a man should think and say what he believes, not dress it!

114

Marvin even once "swore a vow" with Grant that they would never, never wear white tie, tails, and topper! Each promised not to fail the other, and each reminded the other when formal occasions arose. Later, at Coe, Marvin was in charge of many of the details of entertaining reknowned artists, and had to don attire a bit more formal than everyday clothing. But even then, Winnifred says, he refused to wear a stripe down the side of his trousers.

Winnifred and Marvin were, as Winnifred says, "poor" in those early days, and could not afford the opera, theater, or costly recitals. She says it with no lack of cheer, for they had their friends at the college, friends in the community, and best of all, the friendship and companionship of the young artists.

One writer has suggested that the Cone home was *the* "hangout" for the artists. Winnifred denies this. Marvin had no time for such a place; he was too busy. But their home was a frequent calling place for Grant, the Keeler brothers, especially Charles, the etcher, and "the air was filled with paint talk."

Winnifred and Marvin loved biographies, histories, travel books, and books about artists. They often read aloud, and no book was just for show. Their books collected rapidly, and they asked Grant's advice about what to do with them. Grant suggested floor-to-ceiling shelving on either side of the side window in the living room, the lower parts to be storage cupboards.

John Reynolds in an article in the *Gazette* in 1947 spoke of the Cone library—all of the books read, some more than once, many aloud. In that same article, "Profile of an Artist," John described Marvin and Winnifred's life and Marvin's work:

The Cone home is cheerful . . . on Saturdays, holidays, and weekends, a visitor is bound to find the dining room table leaves-down, pushed against the wall, for there Marvin paints. Is his wife discommoded? Not at all! . . .

Cone is just as serious about his professorship as he is about his painting. He has classes four and a half days a week, and on four nights a week he prepares lectures he delivers before the divisions in Art Orientation, American Painting, and Modern Painting. He also teaches painting and drawing and cooperates with the Humanities course in which are correlated music, art, architecture, science, and literature.

No lover of things mechanical, including a typewriter, he writes out his lectures in longhand. "It's the only way I can get them into my head," he says.

The Cones, in spite of all that was written about them, were not perfect; they were *people.* There was a live-and-let-live atmosphere about them. I know of no one who has known the Cone home, then and now, who does not still feel that even with Winnifred alone in it with her dog Cindy, it is a place of warm friendliness.

The Cones not only entertained their friends in their own home, but were usually among the faculty hosts for artists who visited the campus. The many conferences and festivals held by both Coe and Cornell College brought symphony orchestras, singers, actors, authors, painters, and scholars to this area. The same circumstances which had given rise to Greene's Opera House made this possible. Cornell College, in Mount Vernon, is only sixteen miles from Cedar Rapids. Transportation from Chicago was relatively easy.

Marvin and Winnifred met these people, respected them, enjoyed them. This social and professional contact, and personal contact, made up to the Cones to a great extent the social and concert affairs they had had to miss when they were young.

Art exhibits were often held in conjunction with these affairs. One memorable exhibit was held at Coe in 1952, and the *Gazette* poked some fun at the In-Charge-of-Art Man, Cone:

It is reported that right now Marvin Cone is in the middle of one of his most precarious projects in the history of Cedar Rapids. One false move, one slip, would be a disaster. It is his responsibility to uncrate the highly valuable paintings loaned to Coe in celebration of the Centennial Fine Arts Festival. Each painting, and some are very large, is packed in a heavy wooden box.

Twenty-four of these are coming from New York City, Omaha, Detroit, and Chicago. The Metropolitan Museum is sending three: a Rembrandt, a Rubens, and a Van Dyke. In value and prestige, this is the greatest exhibit ever shown in Cedar Rapids; it must be guarded day and night, with extra armed guards on duty during exhibition hours.

Marvin Cone delighted in getting into trouble. Once he was "discovered" by a college dignitary who happened in, busily painting on a picture hung for the exhibit, concentrating, busy with brush.

"What in the world do you think you're doing, Cone!"

"I thought these fellows a little dull. I'm brightening them up."

116

"You mean to tell me you think you can improve on those—those painters?"

"Oh, yes. They get rather dull in their travels."

"But man—aren't you very presumptious? Really . . ."

"The frames get scratched and rubbed, you see, and I'm just touching them up."

"But, pardon me, aren't you working on the face in that painting right now?"

"I am indeed. This painting of Thomas Sinclair got damaged in the chapel fire, and I was asked to make him as presentable as I could, to go back in his place. We would have missed his money. And we would miss him, wouldn't we?"

"I hope you have some experience at this sort of thing."

"Oh, I have. When a mere child I peeled off paper that was glued to the glass. And I have been swinging brushes ever since!"

Marvin smiled reassuringly at his visitor, and went on with his painting.

Marvin was always very free with his time for the cause of art in the community. He spoke to many groups about art, and people of the community had the idea that Marvin, now with a full-time job at Coe and putting in so much time on work for the Art Association, "just wasn't doing any painting on his own any more. He's given it up."

"GIVE UP PAINTING!" said Winnifred, in those tall letters. From what she says, I have deduced that he left his classroom and studio at Coe, went straight home, opened the door, shucked off his coat, and headed for the painting equipment, all without breaking stride!

Marvin's early home on the Coe campus was the top floor of old Williston Hall, once a dormitory, which had so far withstood the strong winds from the west. Mae Wolfe, faculty wives, and patrons held an exhibit up there of Marvin's work. The student reporter wrote:

For the last two years Mr. Cone's interest has centered on still life, for there are more of these than any others in the exhibit. They are interspersed by landscapes and two sketches, revealing the range of ability possessed by the artist. . . .

Of the painting, *Arc de Triomphe*, the reporter said: "The accentuation of colossal lines of the beautiful monument and drab grey texture used to emphasize its simplicity make the picture one of profound impressionism."

When the Stewart Memorial Library was built on the campus, in 1932, the library collection was moved from the top floor of Old Main to an elegant, spacious new home. Marvin's art department moved from Williston to the top floor of Old Main—a building as old as Williston, but broader in the beam, sturdier. The moving day was reported in the *Coe Cosmos*. The article described a moving line of students with chairs, easels, equipment, brushes, cans, nails, thumbtacks, chalk, clips, and odd papers dropping on the way. One student, reportedly, looked behind him at the trail and said, "Well, if we want to get back to old Mother Williston, we've left a trail we can follow in the dark."

All of it got up there, eventually. The walls were painted white, and the new, greatly appreciated space enabled a student to work without bumping his neighbor's elbow. There was also more room to hang paintings. The new library accommodated exhibits especially well, and that, too, was an improvement.

A *Cosmos* report of the period was headed, "Coe Art Students Sketch From Life." Marvin reported here that sketching in charcoal from real life was popular with college classes, and that there were both townspeople and students in the project. He added that the results compared favorably with the work done in art institutes across the country. Marvin also sent out a plea for models, in swim suits (no heavy police boots thudding up the stairs of Old Main!).

In a later story, a student wrote:

Instructor Cone started at Coe with just a small drawing class. Perhaps you have heard of the informality of Professor Cone's drawing classes. Or you may be one of those students asked, "How about posing for us this afternoon?" You gladly give up an hour of P.T. for a quiet hour of relaxation as a model! Happily, the art students lead you up to the third floor of Old Main. From then on, your life isn't your own.

You jump up on the platform. You feel like a dog being put through its paces. Put this hip *up*, put that arm over *there*, and they direct you in a series of contortions never heard of before. After a while, they select a pose for you, and the drawing begins. They pull you apart, limb by limb, and try to draw you back together again.

118

The payoff comes at the end of the hour when they show you their products. Some aren't so bad, but others—my word! They don't even look like you. The action and the proportion of the picture really count, says Prof. Cone. Knowing that you couldn't draw the handle of a left-handed monkey wrench yourself, you feel flattered. You promise to dash back at the earliest possible time.

Yes, we like Mr. Cone's classes. They are so informal and so enlivened by his wit and humor. The students who seek help in their drawing are also acquainted with the rich philosophy of life which the art students reap from his lectures.

The *Coe Cosmos,* besides printing articles about Marvin, also printed some which were written by him. One of these, in November, 1944, was headed, "Fine Arts Are The Best Analysis Of Man." Marvin wrote:

The urgencies of war demand rightly that the college stresses that which is immediate, practical, and necessary for victory—scientific knowledge and various skills which have direct bearing on the protection and saving of priceless lives. American colleges and universities could do no less. The protection of a physical life is paramount, for bound up in it, with it, is a human being, a self, a personality, a human mind, or spirit. To offset the damaging effects of the disease of war, we must have potent nourishment.

Modern education has paid too little attention to the spirit of man, has thought too vaguely and loosely about it. Mind and body have been amply provided for. Rich personality has been assumed as the result of acquiring knowledge, a by-product which somehow appears automatically, provided curricular requirements were properly fulfilled.

What a conception!

More intelligent are demands for expansion of spirit than for specialized training to equip a man to acquire the necessary utilities of life—a sandwich, a coat, a roof. These three, as goals of education, are not satisfying for long. For a century the human spirit has lagged behind material progress for lack of food. Values have been distorted. In times of war and prospective peace, values which have contributed to war must be revalued.

The fine arts as part of a humanities program in a liberal arts college function primarily in the field of the human spirit. As the spiritual heritage of the race, they define man, bring him into focus. . . . The arts train toward sensitive perception, discrimination, and judgment, demonstrate the worth of reflection and discernment, mature and perfect personality. They widen the circle of "things to cling to"; they pull upward making possible the enrichment which follows contact with enriched personalities; they reinforce our belief in the basic goodness and dignity of man.

119

Education in the arts increases the values upon them; the arts become alive and energizing as we catch life from them, for they document abundant experience and suggest the meaning of life, to man. As such, they possess powerful re-creative value.

One familiar with the arts inevitably unravels some significance in the adventure of living. He acquires a philosophy that satisfies and maintains an optimistic outlook toward tomorrow, sure that the heights that have been attained in the past cannot only be reached, but can be surpassed.

Let us not pretend to be mature as long as we are adolescent in respect to many of the qualities essential to maturity. The latter implies peak form, normalcy, fullness, richness, and flavor.

The arts signalize these qualities in human beings. They allow us to savor man. They deal ultimately in intangibles, but by these man lives. . . .

An intelligent study of the arts of man is one of the surest ways to develop *awareness,* certainly one of the marks of the truly educated man, and to produce, as Henry James said, "the kind of person on whom nothing is lost."

Marvin himself always thought of his career as one of guidance rather than teaching. He said:

It seems to me that the good teacher usually finds the true capacity of a student, an individual student, and develops it. By doing this, the student has a chance to develop himself. To teach How The Teacher Paints would be *treason.* But if I had only one idea to pass on to the students, it would be: Keep on painting, and *then* worry about the theory of painting.

His students knew that this teacher held not an ounce of complacency. He never stopped believing that he could *do better.* Nor was this ever a pose. It was quiet integrity.

Marvin was anything but inarticulate. He talked to students, alumni, to the Art Association, and to community groups. In fact, Marvin talked so much that anyone who saw him, mingled in a group with him, looked at paintings with him, visited with him socially, was bound to absorb some of this painter's natural wisdom—never given as such, but as his ordinary outlook on life and his feeling about people. He was asked hundreds of questions.

"Where do you get your ideas?"

"Appetite comes when you eat," Marvin translated from an old French saying.

120

A Portfolio of the Art of
MARVIN CONE

A LITTLE YELLOW HOUSE on a quiet street in Cedar Rapids, Iowa, remains today the most meaningful gallery of the works of Marvin Cone. Here, where Marvin Cone brought his bright-eyed Canadian bride, the surroundings are warm and unpretentious and here Marvin Cone paintings proudly line the walls in the studio where his easel still stands; in the friendly living room with its bookshelves suggested by Grant Wood; and in the modest dining room the artist once used as a studio.

"He nearly always painted by daylight," his wife Winnifred recalls. And in daylight, with the sun streaming through the house's many large windows, the Cone paintings—famous ones like *Davis' Dummy* and truly personal endeavors like the untitled study of his lovely wife—take on their true posture.

In this home-gallery, one sees the stability of Marvin Cone, the artist, the teacher, the dedicated husband and father, the staunch supporter of art in his community, and the loyal friend of so many people, including, of course, Grant Wood. A life's work is represented here—a life's work which took the artist from the Iowa barns he painted so beautifully, and for which he became so famous, to the angled doors and stairs which led him to the striking abstracts of his later career. And a man is represented here—a man whose humaness shows so dramatically in his carnival scenes, in his self portrait, in his characterizations of Uncle Ben, and in *Dear Departed*.

Cone paintings, of course, have scattered far beyond the family favorites in his home, and beyond even the collections at Coe College, where the artist taught, and the Cedar Rapids Art Center, which played such a monumental role in his life. But it is the art of Marvin Cone still cherished and held by those closest to this artist—his immediate family and his community— that is presented in this showing of his work.

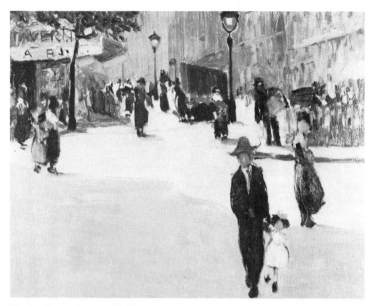

Paris, Street Scene, 1929
oil
Cedar Rapids Community School District
On permanent loan to Cedar Rapids Art Center

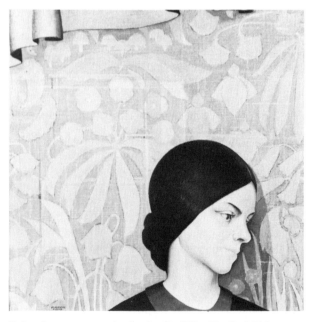

Color Arrangement, in the Studio (Winnifred), 1929
oil
Mrs. Marvin Cone, Cedar Rapids

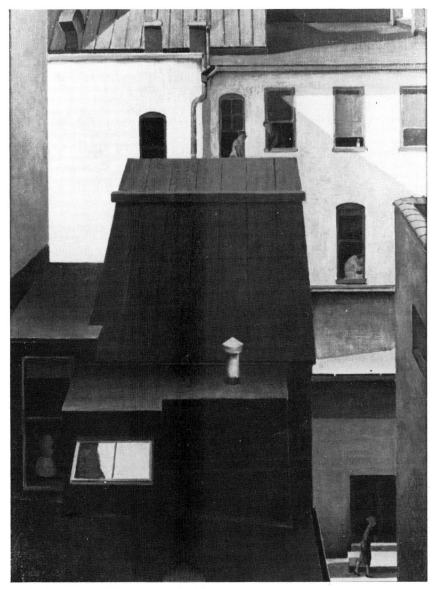

Davis' Dummy, 1938
oil
Mrs. Marvin Cone, Cedar Rapids

Dear Departed, 1939
oil
Mrs. Marvin Cone, Cedar Rapids

Carnival Scene, ca. 1939
oil
Mrs. Marvin Cone, Cedar Rapids

Self Portrait with daughter, Doris, n.d.
charcoal on canvas
Mrs. Marvin Cone, Cedar Rapids

Ghost, 1940
oil
Mrs. Marvin Cone, Cedar Rapids

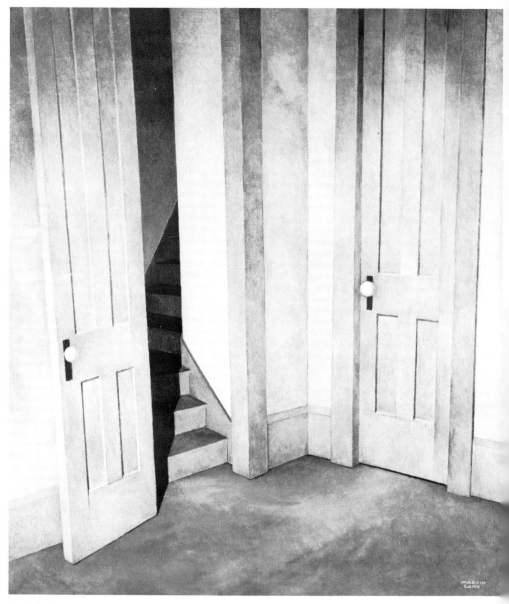

Attic Stairs, 1952
oil
Mr. and Mrs. Owen Elliott
University of Iowa Collection

"I know nothing about art," people would confide in him. "Neither do I," he would answer.

"There is so much change in art, I never know which is the best style to choose."

"Art is the most permanent thing in the world," Marvin would answer, "and painting reflects the spirit of the times as faithfully as does literature or music."

Visiting with a group of students at the University of Indiana, Marvin was asked the inevitable question, "Why does a painter paint?" Marvin gave his usual answer, always delivered with spirit, "Because he'd rather do that than anything else!" Asked why he went from one type of painting to another, he answered:

When you learn all you can about arithmetic, you store that knowledge away for use when you go on to algebra, and that valuable material puts you on to higher mathematics. Arithmetic is not lost, but you don't play with it for its own sake any more. The musician who becomes proficient in the difficult classics doesn't return to the exercise books, even though they, too, in their simplicity, have been classical. A painter doesn't stand still, ever. He explores to the full one field, then moves on to one more challenging at the time—and so on. You may know Grant Wood's painting, *Arnold Comes of Age,* the painting of a young man [Arnold Pyle] striding forward almost right out of the picture, with all his youthful toys and gadgets and games strewn in the background, behind him.

Speaking to an older group, the American Association of University Women in Cedar Rapids, Marvin said:

In the history of ancient countries the statue carved by the sculptor becomes of far greater worth than the huge business organizations and labyrinth of offices, its battalions of secretaries and its nationwide delivery of goods. In art, we trace the spiritual history of the race. "The glories that were Greece" are not the trading centers or the financial markets but rather the manifestations of the arts.

Great art never needs revision because it is always true. The great cathedrals are not out of date. The paintings of Botticelli are not out of date. Contemporary art is alive. For one must be alive to recognize life. Appreciation and enjoyment are the result of the collaboration of artist and spectator, musician and listener, poet and reader.

To the student who came to Marvin to learn how to appreciate art, Marvin said, "Study! You can *enjoy* art without study,

121

but you cannot *appreciate* it." This brief, blunt answer was very characteristic, but never came out unkindly. Marvin never had to fumble around for answers. About art, he was always clear.

One of Marvin's many appearances in the community was before the Cedar Rapids Women's Club. The chairman of its art department asked Marvin to paint on the stage a work which the department could give to the club to hang in its new building. That Marvin consented to do it did not surprise anyone. Winnifred was often amused at the requests made of him, but he was gracious, and usually agreed to them.

Whether Marvin knew it or not, while he painted before the large audience on the flower-bedecked stage, he was accompanied by the singing of Ben Jones of the Coe Music Department. The selections included, "Where My Caravan Has Rested," "Dear Old Pal of Mine," "Heart of a Rose," "I Hear a Thrush at Evening," "The Barefoot Trail," and "Mother O' Mine." Neither Winnifred nor I can keep from laughing, almost hysterically, as we remember that performance and those dear, dated songs that Ben Jones sang with such feeling. The painting, of course, is still a very precious possession of the Women's Club.

People, especially students, always loved to listen to Marvin. At the 1937 Coe commencement, he was speaker for a special event held in the staff room of the library. Seventy-five people crowded into the small room, and he left them with no doubt as to his convictions when he affirmed:

The artist paints, not to imitate nature, but to express individual ideas he feels himself. . . . Art is lots more fun if you don't demand that paintings look like the real things. Nature is terribly chaotic and wasteful. The artist sees this and takes the bewildering matter and puts it in order, giving it meaning.

Art rearranges nature. What you leave out is often more important than what you put in, because that fact focuses emphasis on what you do put in.

Every painting must have good design. It is fundamental in art, all kinds of art, and in painting it must be color, line, and tone.

He also urged his audience to welcome the difference that invariably lies between the artist's theme and the patron's conception, and reminded them that a famous critic had said, "Art is not an escape from life; it is an involvement." "To me,"

122

Marvin said, "business is an evidence of man's struggle to live; the fine arts are an evidence of his living."

A question often asked of Marvin, who had studied abroad, was, "Is America as paintable as Europe?" Marvin's reply was:

Anything that has form, any place, is paintable. . . . An onion is more paintable than a rose. From an artist's point of view, the form of the onion is easier to grasp and appreciate than the form of the rose. Both are beautiful.

Years ago, the beauty, the picturesqueness, the history and the tradition of Europe and its older civilization made it necessary to visit, especially to attend a good art school. Our young painters flocked to Paris, Munich, attracted by marvelous architecture and art, the result of long contact by man with the land. No one denies that Europe is beautiful.

Paintings brought back from Europe were good, sold well, the scenes were different than those seen in America, in our own country. But the situation has changed and is still changing. The greatest created art is still to be seen in Europe. But most people are oblivious to the beauty around them, which breeds indifference, if not contempt. We go around with closed eyes, figuratively.

But for the artist, material is everywhere. It may seem harder to hunt for in Cedar Rapids than in Paris, but it may be that fact which develops in the artist a degree of attainment which he could not otherwise reach. Artists are very individual persons; going abroad or staying home is an individual matter. Any artist whose ability has been "ruined" by European study, whose Americanism has been thereby lessened, must have had very mediocre qualities to begin with. Great art demands great human beings behind it!

For Marvin, speaking, being the attraction on a program, was just another way to bring art to the people. He never spoke about Marvin Cone or his success, but always about art, about man, and about the ability and competence of young people. When he was approached about the honors his paintings won, he was inclined to be offhand about it. "I'm glad they liked it." "I was pleased to have got in." "I was lucky."

Marvin made notes when he was called upon to review an exhibit. He may have written out special speeches for other occasions, but no collection of manuscripts exists in his scrapbooks. About art and its relation to life and man, words just spilled out of him at any time.

A strong feeling of pride prevailed among the students who studied under Marvin at Coe, who knew him on the campus,

123

or who had worked with him on any of the many campus projects with which he was involved. Betsy Flodin, writing in the *Coe Cosmos* in 1941, comments:

. . . many a Coe student from Professor Cone's classes will be able to point an admiring finger at many outstanding paintings in many outstanding galleries far away, and tell . . . "I knew that man way back when . . ." But not when he was temperamental, or throwing a fit, or trying to get attention to himself, or transferring the blame somewhere else if things didn't go right. No indeed! They'll never be able to pin anything like that on artist Cone, known on the Coe campus for the past 20 years as one of the most mild and gentlemanly of professors.

Never by word or deed would anyone guess as he goes quietly about his work of guiding students . . . that during this very month, his paintings are being exhibited in our greatest middlewestern art gallery.

Professor Cone concentrates on quality . . . his work advertises our college and our city and our state. His patience, simplicity, kindliness, friendliness, sincerity, and above all his inimitable sense of humor change his class periods from work-a-day world hours to ones that will be long remembered by all who enroll in them.

Marvin must have winced at all this. I am inclined, like Betsy, to do him this injustice, because I liked him so much, and knew him in his own time. Yes, he was blunt, outspoken, often curt, quickly disclaiming what he considered an untruth, intolerant of the "pretenders" among the artists, but he was never rude or unkind. Winnifred has said, "He liked people. He respected them. And he could always see the funny side of things, including himself."

Many visitors to the campus have been heard to remark, "To tell the truth, I was a little disappointed. Marvin Cone just doesn't *look* like an artist." Many spent much time in pleasant and interesting conversation with him without ever finding out who he was.

The Cone Art

It was not that Marvin Cone, the teacher at Coe College, *lacked* attention for his art, but the noise his friend Grant stirred up quite naturally turned the minds of the community in Grant's direction.

No one appreciated this fact more than the Cedar Rapids *Gazette,* which had given Grant not only personal but special coverage, keeping pace with the eastern news, and allowing its writers to run their own rope, or spin their own yarn. The editorial written by Verne Marshall, who had certainly befriended and honored Grant, written after Grant moved to Iowa City, spoke for the community:

> As it becomes news that Grant Wood is about to establish his residence in Iowa City, after bringing to this city attention to his high achievements in the world of art, another Cedar Rapids man gains recognition by winning acceptance at the annual State Fair Exhibition.
>
> Marvin Cone has long deserved the honor accorded him, and more. Less spectacular than Mr. Wood's, Marvin Cone's work, nevertheless, is favorably comparable in quality to that of the young man whose national fame followed long years of quiet and persistent efforts. The local careers of these two men have been similar in many ways. It would be a fine coincidence if Cone were now to follow in deservedly wider acclaim for his work.

Marvin wasn't really a "regional artist," although he was a contemporary of the three famous regional artists, Curry, Wood, and Benton, and of course, knew them all well. Regional art is defined as the painting of a certain definite, recognized area. It is difficult for people to understand why all artists are not "regional" painters. Marvin Cone might be an explanation. Although he did most of his famous painting in Iowa, in Cedar Rapids, his work had meaning to people almost everywhere on

125

earth. Iowa landscapes gave him his thought about landscapes and clouds, but those he painted might have been anywhere. His work was introspective and ranged into the hearts and minds of people as he developed.

If Marvin missed the fame of the three regional painters, he also missed the violent reaction to them in many circles. Curry never found comfort in his home state of Kansas, where the people thought he had "ridiculed" them, and Benton lived and worked away from his Missouri for many years.

Wherever they were, these men sought aesthetic values in penetrating to the meaning and forming of life, *as lived*. And for all of them, this meant an American life as known and felt by Americans, ordinary Americans. This belief often offended those who lived "above" and who believed that art itself should be "above vulgar contacts." Benton said, "The critics couldn't be bothered to work this out—they just called us fascists, chauvinists, isolationists, and at the least, just ignorant provincials—and dismissed us." Benton concluded that provincially minded people can live anywhere. "The same damned bores you find in the penthouses and studios of Greenwich Village hang onto the skirts of art in the Middlewest," he said.

Both Curry and Benton envied Grant and Marvin their acceptance in their home town and their state, their support by the Art Association, and the total cooperative effort to help them attain their painting goals. Marvin, however, thoroughly enjoyed the "disturbance" created by Tom, John, and Grant. And that they could accomplish this disturbance throughout the whole art world of their country just increased his admiration for all three of them.

Many of the regular columnists and reporters from the metropolitan newspapers knew both Grant and Marvin's works, and often spoke of the two in comparison, appreciative of both. The well-known Mr. Bulliet of the Chicago *Daily News* once whipped into Grant, however, over the back of Marvin Cone. "Cone," he said, "painted rolling hills that Grant Wood, his neighbor, had overstyled. They are not as spectacular as Wood's, but their lack of obvious trickery makes them much more enduring."

I have hunted hard to find some resentment by either Grant or Marvin to a seemingly unfair or comparative criticism. I can-

not find it. They chuckled, they laughed, they took adverse criticism as a good joke. They never took exception to a judge or his findings, and were far more inclined to keep their ears open for some criticism which might be of help, or some lack which called for improvement, more work, more knowledge.

All in all, I think these artists were so happy to get into an exhibit, to get that much recognition, to have a judge or jury notice them or mention them, that there was no room for displeasure. They were aware that in the eastern museums and galleries they were up against the strongest kind of competition, up against the most severe and outspoken, best-informed judges, and like a runner who half-way collapses at the end of a hard race, they were glad to have "made it."

Grant disturbed people. Marvin stimulated people without violence or noise.

Marvin moved through a variety of subject matter in his career. Clouds were one thing, landscapes a broader field, more challenge. Still life was a recurring interest and challenge. Barns came from all over the countryside. He was in fact his own school of art, getting, as he explained so often, the most out of every type of subject, milking it dry, then moving on to a greater challenge which had developed in his mind, and getting everything a painter could out of *that* challenge. Once work started, the new challenge started to emerge at once.

Those who talk *about* Marvin point out that he "grew up" every day of his life. The young writers on the *Cosmos,* quite on their own, said, "He keeps getting younger every day, as he 'grows up.' "

Of his early work in France, Marvin said,

In France I became an Impressionist, like nearly all the young American painters in Paris. When I began teaching at the college, I became interested in still life, then clouds, circus and carnival pictures—people here and there—and for a few years barns and landscapes. I'm monkeying with material that people speak of as haunted houses. They are all done from imagination and seem to offer me more opportunity for design than previous material had.

Thunderhead is one of Marvin's stunning cloud paintings, one that in an exhibit draws you to it the moment you enter the gallery. I had "lost" this painting; evidently, in its early ex-

hibiting days, it was bought and taken away. Later it turned up in a Coe exhibit, and Adeline Taylor wrote of it:

Marvin Cone's special coloring has often put him in the "modern" class. The unusual coloring of *Thunderhead* would easily put it in that class. You and I fail to see how a painting of the eternal clouds in the sky can be *modern*. But color, in the hands of a painter, can be very different, and once you have been told about it, you see the fascination color works.

It turned out, of course, that a "local," Mrs. George B. Douglas, had bought the painting and had loaned it to the exhibit.

Of a later Cone exhibit, John Reynolds wrote, "I've nothing more to say about clouds, but aren't they *nice*. Sincere (the artist), and with a wonderful sense of humor. And if you don't know him, that's probably his fault because he is as modest as a period in a 60-word sentence."

One evening, seeking relief from Iowa's summer sultriness, Marvin, Winnifred, and Doris rode up to Center Point. While Doris rode the merry-go-round, Marvin and Winnifred watched the goings-on around them—side shows, barkers, people. The "notes" Marvin took, without aid of pad or pencil, have come to us in a series of carnival paintings. *Village Merry-Go-Round* has the evening sky, the merry-go-round in the background, and the street light illuminating the crowd. There is a couple holding hands around a telephone pole; Ma, with the kids climbing stickily over her ample frame; a pair of boys sitting on the platform, counting toes. It was critically called quite a study in design, and I am bound to add, quite a study in human nature.

Educational Exhibit is a clown, a snake charmer, and a barker. The artist found something even funnier in *Freaks,* the people in the audience, and he even painted himself into that picture. Whenever these paintings are shown, viewers always seem to find "someone they know" in the pictures!

It is hard to explain why Marvin Cone's barns, in their variety on canvas—some of them modeled after actual old barns on Iowa land—should win prizes and acclaim. But old barns, like the old houses that came later, have made history and hold secrets. The lines and angles made the design. *Two Barns,* which was one of only 300 survivors out of 5,200 entries in a Carnegie show, was inspired by two old barns in the Ivanhoe Bridge area between Cedar Rapids and Mount Vernon.

128

In 1938, when Marvin took his sabbatical year of absence, he worked right in town, except for a few weeks he spent in Mexico. Marvin took space in a downtown office building and set up a studio. A *Gazette* writer, Wonda Montz, "smoked him out" in his downtown room, and they visited. Wonda reported this interview:

He was on the top floor of an office building with the welcome sign as carefully hidden as a dog's buried bone. It is the first time in his whole life he has had a whole year just for painting, eight hours a day, no telephone, door locked. He is having the time of his life!

If he wants to see people, he goes to his window and looks out. Occasionally he goes down across the street for a glass of milk. The rest of the time he is on his own desert island. Even his best friends don't know where his studio is located and he hopes they'll never find out.

In half of his year he has done about twelve paintings and some charcoal, and what now? "You just keep painting," he says, "and the first thing you know you've painted a good painting—and there is your best reward."

At this time, interested in ghosts, he remarked, "I don't think a ghost is a trivial matter. A ghost is international. No, I've never seen a ghost but I *like* ghosts."

At the downtown studio, he explained that because that place did not have a north light, in which case the light would always be the same, he had to work on a picture at the same time of the day, each day.

At the outset of that year off Marvin got the impetus he needed for his triptych, a panorama in three panels, that presented a broad scene of river hills. The Chicago Art Institute accepted his *Triptych Panorama* for its forty-ninth annual exhibition of paintings and sculpture.

The year in the downtown studio also produced *Davis' Dummy,* which was shown in Des Moines, at the Chicago Art Institute, and many other places, and was a prize winner. Marvin happened to paint it because there was a tailor shop opposite his window, and he could look in. "I hope the tailor doesn't sue me for libel," he said.

Marvin completed forty paintings that year, twice as many as he had anticipated. Asked how long it took to do a painting, he answered that he had spent as much as three weeks on a canvas, then destroyed the effort when he realized the idea had failed.

Others asked him, "What's the hardest part of a painting?" Marvin answered, "Thinking up a name for it."

Winnifred tells of a painting Marvin had done of a fellow with a marvelous mustache. The family asked what was going to be its name. "Oooh," said Marvin, "probably Charley."

Probably Charley was its name.

Following the year of painting came the exhibit of Marvin's paintings, and then the auction. Verne Marshall wrote in the *Gazette:*

At the Carnegie Institute in Pittsburgh, Elmer Stephan, director in the public schools, is about to begin his fifth season of classes for adults who don't want to be artists, but would like to know what Art is all about. "I am trying to tear down the impression that Art is a mystery and that Art Exhibitions cannot be understood by the man in the street," explained Mr. Stephan. "There is nothing mysterious about painting. If it is good, it will bear analysis. I disagree with artists who sneer at the public for not understanding their pictures. After all, they live only because the public goes to them in their shows."

The primary requisite for understanding art is to see enough of it. That may not make for the understanding that enables one to talk knowingly to others in the pseudo-technical arty jargon affected by many who feel that art appreciation is an essential social trapping, like the ability to stumble across a dance floor, or play a passable hand at bridge. What it will do is enable even the unartistic to see nature through skilled eyes of artists who have the ability to strip it of all its confusing details and reduce its many moods to simplest terms. In almost every art exhibit there are a few paintings that will give the lay observer a type of deep satisfaction he could get in no other way.

To test that assertion, the people of this community need only to visit the gallery of the Cedar Rapids Art Association and spend some time looking at the current showing of Marvin Cone's work. It doesn't cost anything. On the contrary, it pays dividends on the investment of nothing but time.

Marvin Cone's ability is recognized by professional critics qualified to appraise it with expert eyes. But one needn't be an expert to enjoy it. Some of his canvases now on display will thrill the lay observer to the toes, setting up trains of associated thoughts and emotions that recapture, crystallize, moods he felt but never could express. Whether that is what Mr. Cone intended them to do we don't know, but it is a great contribution to the richness of other peoples' lives.

It was the auction of these paintings of Marvin's that brought Grant Wood back to Cedar Rapids. Part of what he said that evening has already been reported. He also said, of the exhibit:

Another quality stands out . . . a rich vein of what we call, for lack of a more serviceable word, the poetic, which lends to the best of it a special depth and inner vibrance. These two qualities, the poetry and the clear, direct representation, have always been present in the artist's work.

The painting tells us a good deal about the man. He is an intelligent, self-possessed individual, too modest for his worth, full of enthusiasm for the art of painting and all the arts of living. Shy, kindly, he nevertheless speaks his mind with a blunt honesty that does not always charm the ear. He's a man's man, with a good digestion, infinite common sense, and a booming, infectious laugh.

His life has been devoted to the enrichment of the community in which he was born. His community, Cedar Rapids, in turn, have bought his paintings and appreciated his influence. The sponsorship of the artist by his fellow citizens was a civic project of the highest order. Here, on these walls, is living proof that the venture, the investment, was worth while.

The auctioneers that evening were all special friends of both Marvin and Grant. They included Arthur Poe, Donald P. Barnes, Eugene M. Pinney, Verne Marshall, Frances Prescott, Edward Sheehy, Dr. W. E. Peschau, Howard R. Green, Don Hines, Jack Shepard, Marvin Wright, John C. Reid, and Walter J. Barngrover. I, too, had the privilege of banging the gavel for sales for Marvin.

The bidding started slowly, rather self-consciously, but the natural insulting talents of the auctioneers soon found full voice, and the old room resounded with spirited bidding. A group of twelve private citizens paid $540 for *Old Iowa Barn* for the collection of the Art Association.

A letter from Will Boyd and David Turner reported the financial part of the affair:

It is with a great deal of satisfaction that we make our final report on the Marvin Cone Fund. Marvin had a wonderful time in the full year he had to devote to his art, and he certainly made the most of this opportunity. All expenses have been paid, including all the money advanced by the sponsors. The loan of your money and your friendly interest has been of untold value and a wonderful inspiration to Marvin Cone. We are sure you will never regret your part in this worthwhile project which has cost no one any money and has given us all a great deal of enjoyment.

Marvin Cone's pictures will increase in value. If you do not own some of these paintings, you are missing a good and satisfactory investment.

Many years later, on a radio program Mary and I conducted with Marvin as our guest, he said:

> . . . it is wrong to think that the buying of original paintings is something for those who are "up in art" to do. Think of all the paintings owned right here in Cedar Rapids, on permanent exhibit, you could say, in private homes! Sure, people buy paintings, Originals!
> When you realize that these people sent me to Paris, to Mexico, made it possible for me to have free time to paint, what can be said to top that generosity. And there is the Art Association—and what it has done for all of us. I shall never forget that!

We talked on the program about the theater and how the community group missed him. "Yes," he said, "after I built Coe's theater in the basement of the chapel and made the scenery for their early plays, I hoped that the Community Players might have a theater of their own some day."

When Marvin moved from barns to houses with ubiquitous "Uncle Ben" on the walls—"haunted houses" some called them —James Allison Flynn, in the *World-Herald* magazine *Arts and Critics* wrote on "Marvin Cone and Uncle Ben":

> Marvin Cone is an artist who has chosen not to eschew his own locale in the pursuit of his career. The roomful of his canvases now at the Joslyn Gallery give ample testimony to the wisdom of his choice. Marvin Cone lives and paints in Iowa; Cedar Rapids is his home town and he is the head of the Art Department at Coe College. Everything in his world reflects his lively interest, the keen stimulation his immediate environment holds for him, and the deep affection he has for it.
> You may find yourself inclined to divide these paintings into three groups: the Landscapes, the Figure Paintings, and Interiors.
> In the landscapes, he is at his best where he forsakes detail for rugged and elemental forms. *Little Bohemia Tavern* and *Cook's Barn,* for here there is color, mud, manure, red walls, peaked roofs. . . . Marvin Cone paints these battered barns almost as if they were portraits of noble and majestic old humans. It is a remarkable thing, but Mr. Cone's barns seem to have more life in them than his humans, than Mr. Cone's people, except, of course, Uncle Ben. The people . . . don't quite come off.
> But the Interiors do, and HOW!
> Here, Marvin Cone has something which is quite different from anything I've seen in painting. There are several of them, delapidated all, and somber, the rooms of deserted old houses. *Attic Door #2* is a masterpiece! The simplicity of the forms is monumental and re-

132

lieved and heightened by the design on the wallpaper—the lively detail of the wallpaper pattern. There's a feeling of subdued drama in these empty rooms, empty that is except for Uncle Ben—an old-fashioned family portrait in massive frame, and he appears in his long beard in all the series. His expression varies from picture to picture, now sly and crafty, now mellow and amused. And Uncle Ben brings to the interiors an added quality. A touch of comedy relief. The touch is just right.

A staff writer for the Waterloo *Courier,* Frances Jordan, was most bewitched by Uncle Ben. Frances wrote:

His picture hangs on the wall of an empty house; his eyes are looking sternly and diabolically toward the door which is slightly ajar . . . and then, again, he is resting in his frame on the floor, aware that changes are being made. He turns up later beside a staircase and his eyes look another way and he looks extremely self-righteous. Uncle Ben is quite a guy! Way around on the other wall he turns up in what looks like an ectoplasmic nightshirt, peering around the door jamb.

Uncle Ben was called by many "that delightful old gentleman." In time, I think he will almost become a trade mark. I heard one gallery visitor tell another, "That's the old gent related to Marvin Cone."

Asked about his haunted houses, how he came to paint them at all, Marvin said:

I really don't know how I happened to do the first one of these. It's very vague. I enjoy the sort of eerie feeling you get when you nose around in old vacant houses, old homes—you imagine the people who had lived there and the events that happened to bring this lonely place about. I guess I am just trying to suggest all that. I think the first one I did was an old abandoned home in Stone City while Winnifred and I were spending a month or so there with the Paul Engles.

There were people who did not know Uncle Ben and did not want to. A friend told me that she had frankly asked Marvin Cone to *explain* Uncle Ben and the dreary haunted rooms to her, and that Marvin had smiled and said, "I can't," and walked away. But a friend of Marvin's said, "Uncle Ben? He's people. He's all your life. He knows you all. People, that's Uncle Ben."

Marvin's haunted houses were also reproduced as illustrations. A note of Marvin's has been saved, addressed to Grace H.

133

Gleuck at the art department of the *New York Times Book Review,* in which he says that he is "pleased to grant permission to reproduce *Pride of the Family,* a painting owned by me" in the review of *Haunting of Hill House,* by Shirley Jackson, reviewed by Edmund Fuller.

Night Prowler, Strange To Me Now, and *Habitation* also appeared in the *New York Times Book Review.* When Paul Engle's long poem, "Harvest," was published, it was illustrated by Marvin Cone. *The Daily Iowan* reproduced it with permission of *Life* magazine.

Marvin's painting acclamations went ahead of him like an advertising man. He was included in major exhibits all over the country. *Night Prowler* won a place in the traveling exhibit sponsored by *Encyclopaedia Britannica.*

I asked Winnifred when Marvin became interested in musical subjects. She denied that he ever was. He loved music and delighted in the festivals, and always enjoyed being on a program with Max Daehler, professor of piano at Coe. "What made you ask?"

"*French Horn, Flute, and Piccolo* made me ask."

She laughed. "*That,*" she said, "is one of his abstracts. It was in his mind one time when he heard the orchestra in some number he liked."

This painting, exhibited in a one-man show at Coe College in the fall of 1957, among twelve other "abstracts," was his final painting development. This experimenting with angles, with color, with design, the exploring of the infinite combinations and overlays and impressionistic reactions to the techniques of line and color—this was another new world to the artist.

I heard someone ask Marvin, at an exhibit, why he cared about painting "these modern things." He answered, "An artist likes to see if he can do anything going, he likes to try out all the styles, you know." Marvin said that the angles and lines of the old houses took him on into abstracts, to the color patterns, and to the "modern" and amusing *Housing Problem* and *Habitation.*

A philosopher might find that life for any human on earth becomes more complex, more interwoven, more colorful, more inexplicable—as one grows older. Simple matter and simple sounds become far more complex until we have to see with our

134

minds and hearts, as well as with our eyes. Is it that life itself is more "abstract," withdrawn, but real, as we grow older. Your say is as good as mine. I'm only thinking about it, as I imagine Marvin intended.

Some maintained that the shift of the times to abstract art was due to the tendency of all painters to be exhibitionists, to show off like circus performers, and if they didn't dress the part, to keep changing their styles of painting to get attention. This made Winnifred a little indignant. She said, "Painters are *professional* exhibitionists . . . but they are so in their work, their product, their creation. Not personally. Even then their work looks out, silently, with no sounding voice, exhibiting only itself."

Marvin once said he liked abstractions because they presented a greater challenge to him than representational work. Donald Key, writing in the *Gazette,* put it this way:

Finally, the whole scene, doors, stairways, halls, become strongly abstract in *Housing Problem* and in the same title, number 2, and *Watchman.* The development is natural, intended or not. Cone is one of the thoroughly modern artists who does not paint abstractions just for the sake of being abstract. There is a direct purpose and intent in every brush stroke.

Marvin said:

I don't think people like to be challenged. Certainly the public is confused about abstractions, which are a challenge to the artist and to his audience as well, and I don't blame them very much. The trouble with nonobjective painting is that so few people have points of interest with the artist. In realistic painting, objects appear as familiar images, scenes which have been observed and remembered. In abstractions, the experiences are only those of the artist. However, all good art is experimental at the time it is produced. If painting continued to be the same, this whole thing called Art would die. . . . The new is always thought to be radical when it's first developed. And after a while, even it becomes conservative when an even newer form is derived.

Of his work and his progression in it, Marvin commented:

The only thing that matters while working is the excitement of painting, and it is difficult later to recall when and why certain choices were made. Each picture in progress becomes a stimulating adventure,

135

changing with the ever-present challenge of organizing lines, shapes, colors and values into a design which has significance and is to some extent an expression equivalent to *feeling*.

On one occasion, I visited the Coe Gallery to see Marvin's paintings, looking for one that I could afford to buy as a gift for Mary. I immediately saw a painting I liked, and left the gallery in search of Marvin. When I finally got to him, I told him about my desire to buy the painting, that I had found the very one I wanted, and would he save it for me.

"So you want that for Mary?"

"Well, yes, but she doesn't know about it yet."

"You know it can't leave until the exhibit is over."

"Yes, I know. But I want you to save it for me. I want to pay you, then all I have to do is get it when the exhibit closes."

"You like *The Purple Barn,* don't you?"

"Oh, Marvin—that was *it,* the moment I set eyes on it."

"Well, if you like it that much, I'll give it to you."

"You'll do no such thing!"

"But perhaps you don't want it. It has no frame. That frame is borrowed. Would you mind taking it without a frame?"

"Mercy no. Who could accept the offer of a gift like this— and no frame—how can you possibly suggest. . . ." After such ridiculous talk, we parted.

Some weeks later, a hatless Marvin entered the shop, strode to the back, and plunked down a package.

"Here's your *Purple Barn.* You were so fussy about a frame, I hunted around at home and found one Grant made that just fits it. Here you are."

At that, he turned and strode out of the shop, the door closing behind him. I see *The Purple Barn,* in Grant's frame, as I write.

At the time of Marvin's retirement from Coe, a group of friends contributed $10,000 to make possible for Marvin the title, "Artist in Residence." Under the conditions of the grant, he was to be freed from all restrictions, allowing him to devote full time to his art. Even before this award, Marvin had planned to "retire" at home, and paint. This new consideration gave him freedom to do just that, both at the college and at home. He

136

was grateful, and happy about this honor. Marvin's own comment on his retirement was his wry, "I'm not going to vanish. I'll be around!"

Because Marvin had worked at the college and painted at home, in fairly routine fashion, friends were jealous *for* him. They felt sorry, and said so, that he had never had the "breaks," the exposure, that Grant had had. It wasn't quite fair! Often, their thoughts would be prefaced by, "Isn't it true that . . ."

No, it is not true that. First of all, it has been decided by Winnifred, and to our knowledge, by the other painters, that one does not compare. But we can compare Grant and Marvin in their common drive, their common desire to awaken in young people the sense of the infinite possibilities of the artist's mind and the vastness of the world and the people about them. Grant and Marvin, in other words, had lived and preached *purpose*. Without this, they both claimed, no man could live happily.

Winnifred, pretty, brown-eyed, with an air of merriment about her, has always staunchly defended Grant and Sara and stood firmly in her loyalty to them. The gossip about Grant was rough and unkind, from people who knew little about the whole matter, and from people hurt by his so-called "disloyalty," his treatment of his longtime friends. Winnifred would stand her ground and never be anything but a perfect lady in attitude and language; she would find reason and very human explanations for all that happened. She might admit that it was a marriage that had a wonderful chance of failure, but she wanted to see it a success, if only for Grant's sake. She feared more than anything that Grant was going to be hurt, even when she knew it was inevitable.

Winnifred was grateful that Marvin had been spared Grant's heartaches. She said, "He had parents, an education, and a job. And the Art Association is so kind to him, with their generous exhibiting of his paintings. . . . Painters aren't gods, you know. They are human, and if they are worthwhile, they are never, never satisfied with *themselves*. They never want to go back, just to go *on*, ahead, something more, something hard, to do."

The Cone Exhibits

Marvin's earliest exhibiting was in the gallery of the Cedar Rapids Art Association. In 1929, the Association sponsored a trip to Paris for Winnifred and Marvin. The trip to France was the idea of Ed Rowan, and Ed pointed out, when twenty patrons underwrote the trip, that there was a wonderful return on their investment.

The exhibit of the pictures Marvin painted abroad—forty paintings, plus some sketches—was opened with a tea, and was one of the earliest events held in the Little Gallery in the Palmer Home. The public was invited and 300 came. The painting of Marvin's daughter, Doris, was purchased by the Art Association to hang in the children's room of the Public Library.

Other paintings in this exhibit were: *Pont Nerf, Pont St. Michel, From My Studio Window, Windows—Chartres, Roof Pattern, Promenade—Luxembourg Gardens, Sleeping Village, Madame Charcot's Bouquet, Corner Wine Shop, Market—Mont Morency, Cathedral Front, St. Germain des Pres, Along the Seine, River Balconies—Moret, Luxembourg Pool, Under the Arc de Triumph, Notre Dame—Paris, Street Scene—Mont Morency, Some Paris Roofs, Passage des Postes—Paris, Poplars, From a Paris Window, Chartres, Notre Dame—Early Morning, Paris Park, Normandy Village, Still Life, Sunlight and Shadows, Notre Dame—Abside, Near the Pool, French Countryside, Marigolds, Storm Clouds, Jugs and Buddha, Color Arrangement, In the Studio (Winnifred), On the Wind, Through the Arch,* and *A Latin Quarter Park.*

David McCosh said glowingly of the exhibit:

Excellent draftsmanship and a superb sense of color and design have gone into these paintings by Marvin Cone. His color is always clean whether he is doing a grey day or brilliant flowers . . . this gives the picture an abstract quality of beauty besides the character delineation

138

of the subject. He is one of the few painters who knows when to quit on a painting. The freshness and spontaneity of the first impression is never lost through over-working. His expression is always direct and clear.

Grant at this time saw a very conscious advance in Marvin's painting, and considered this fact the best of all. He elaborated:

. . . still keeping his strong sense of pattern and design, this period of working so long and directly with nature has given a certain depth and connection to his work . . . and has in no way diminished the poetry that has always been so characteristic of Marvin Cone's work.

Ed Rowan said:

Iowa has probably produced greater painters than Marvin Cone, but never a more supreme artist. The pictures in this exhibition show his limitations. As Hourtig said of Ingres, "If he seems a little narrow it is because he is too exclusively an artist." He, Cone, is a perfectionist in detail. He is never bent on amusing or exciting the spectator. Simple, straightforward simplicity—and the more attractive for that reason.

As director of the Little Gallery, Ed had demonstrated a knowledge of art and was articulate in judging paintings. There were times when some of the artists thought him a little overly critical and unappreciative, and because of his preciseness, possibly a little affected.

Winnifred spoke up in this matter:

If the Art Association is worth its salt, it must be honestly critical. The boys want criticism and help, and Edward Rowan was unusually competent to give it and if his style of speaking was a little different to middlewestern ears, his criticisms were wholesome and appreciative without too much flattery, which any honest painter despises.

None of the local painters ever scorned the small-town exhibit or the less pretentious gallery. When they entered those early shows at the State Fair and of the Iowa Artists Club or the women's clubs, they always considered it an honor. No matter where their pictures were hung, they were being looked at and reaching people. And the more ostentatious exhibits always had an eye out for the winners in the lesser showings. When Marvin's

139

Silent Watcher won a purchase prize in Topeka, Kansas, it was then *invited* to the eighth annual exhibition of paintings and sculpture held at the University of Illinois.

Marvin's paintings repeatedly made the educational circuit—the University of Iowa, Iowa State College, Iowa State Teachers College, Coe, of course, Cornell College, Parsons College, and many other schools in Iowa and the Midwest. Marvin's paintings were often hung in the Coe galleries at the time of a special event on the campus, but he would be far more inclined to lead the visitor to the gallery where student work was on exhibition.

In 1941, an exhibit of the sort to please Marvin Cone—the works of four Coe graduates—was shown at the college. From the Class of 1928, Louise Patterson was represented by eleven paintings. Conger Metcalf, Class of 1936, already established as an artist in Boston, had eight paintings shown. Augustus Pusateri, Class of 1940, was represented by one painting. This last person has special interest to the community. In the same Fourteenth Street area where Grant Wood had lived, and where Dr. Mc-Keeby had done "bridge for bridge" up in his office, an Italian family moved into the corner building, thirty steps from the doctor's office. They operated a fruit store in the front and lived in the back. For a time, they spoke little more than Italian. The neighborhood patronized the Pusateris, liked the family, and began, as those things go, to teach them English. English was soon common in the front of the store, but brisk and excited Italian was usual behind the curtain in the living quarters. And there was a small boy, dashing in and out, and probably going to Polk school, which Grant had attended. Here he was now, the third, possibly fourth generation, Augustus Pusateri, entering a painting in the Coe exhibit.

Marvin Cone was the oldest "alum" to exhibit. His three paintings were *Appointed Room, River Bend #7,* and *Cook's Old Barn.* All of these were destined to show their handsome faces far from home.

In 1933, a group of ten of Marvin's paintings were shown at the Memorial Union in Iowa City. That same year, Marvin was showing some "new work" at the Chicago Galleries Association on North Michigan Boulevard. Eleanor Jewett, writing in the Chicago *Tribune,* mentioned especially the painting in

140

which we see Marvin's shadow behind the real painting, the shadow of an agonized painter, hard at work. "Beautifully and exquisitely handled," she commented.

A group of Iowa artists invaded metropolitan Chicago in 1937, with the assistance of the Iowa Federation of Women's Clubs and Carson Pirie Scott and Company. Also in that year, these clubwomen were invited to enter twelve Iowa paintings in an exhibit at the American Arts Society's Gallery in New York City. Marvin was included, with *Hill Farms,* which in its travels, earned at least one "best landscape in oils" award. Arnold Pyle was also included in the select twelve.

In a summer exhibition at the Walker Galleries in New York, Marvin was in good company: John Steuart Curry, David McCosh, Grant Wood, Frances Chapin, Doris Lee, Dudley Morris, and others.

A 1937 folder for an exhibit sponsored by the Iowa Federation of Women's Clubs lists more than forty-two donors and patrons. This is just one example of the ability of the ladies, and the power and backing of the women cannot be minimized in its effect on the painters chosen for exhibits, or in the quality of the judges or jury chosen for each event.

In 1940, Marvin's painting, *From Iowa,* was accepted for the annual exhibition of the Pennsylvania Academy of Fine Arts in Philadelphia, and in 1941, one of his paintings was included in the annual exhibition of the National Academy in New York. Also at this time, the Corcoran Gallery in Washington, D.C., accepted Marvin's *Cook's Old Barn.* The painting had won first prize in a Davenport, Iowa, exhibit. One viewer said, "There's a hell of a lot more to Cone's barns than meets the eye. I feel it, I know it, I've seen it, I've lived with it, but I can't *say* it."

In the New York *Times,* in May of 1941, Howard Duvree commented on the annual exhibition of the Society of Illustrators. He found three paintings worth special mention: a new southwestern landscape by Peter Hurd; an "arresting scene" by Marvin Cone; and *Storm over Equinox,* by Ogden Pleissner. Also in 1941, *Connor's Barn* was chosen for exhibition at the Chicago Art Institute. It was purchased by Wayne King, who later purchased *Prairie Storm,* too. Another Cone painting, *Cedar River Valley,* won $200 at the Chicago Art Gallery Association.

These years of Marvin's constant acceptance in the well-established and prestigious centers of fine art were the unhappy, the difficult, and the ailing years of his friend, Grant Wood. All through this growing recognition, Marvin and Winnifred were concerned about Grant—his work and his happiness.

Marvin's recognition continued the rest of his life. He was accepted and honored at important exhibitions all over the country. His *Pride of the Family* was included in the Carnegie Institute exhibit in 1949; *Dear Departed* was one of 260 paintings selected from 5,000 entries in the Coca-Cola "Paintings of the Year" exhibit in 1946. Marvin was the only Iowa artist represented in the 1951 biennial exhibit of the Walker Art Center in Minneapolis, and his *Three Doors* was shown at the Chicago Art Institute.

Some people assume that a painter goes with and appears with his paintings, wherever they are shown, ready to take the prize money and the bow. But painters can hardly afford to jump across the country making all these appearances. Nevertheless, Marvin and Winnifred accumulated quite a stack of invitations to showings.

The invitations, formal and engraved, are symbols of the tradition of formality surrounding art exhibitions. One from the Corcoran Gallery, addressed to Marvin, read:

The President and the Trustees of the
CORCORAN GALLERY OF ART
request the honor of your presence
at the opening private view
of the
15th BIENNIAL EXHIBITION OF
CONTEMPORARY AMERICAN OIL PAINTINGS
Saturday Evening, March 27th, 1937
at nine o'clock

This kind of invitation would go only to an artist who had entered a painting and whose painting had been accepted. This preview had an ancient name, "Varnishing Day."

Very rarely was Marvin on hand to appear with his paintings. But he did hear from viewers. He occasionally received a note like this one, from Richmond, Virginia:

142

Dear Mr. Cone.

Since the Biennial Show here I've been wanting to thank you for the great enjoyment I had in seeing and recalling your *This Is the Door*. It gave me pause—a lovely silent time contemplating the delicate "sensitive awareness" that could conceive and render it so beautifully. Thank you so much.

With all best wishes,
IDA MCCOY

I can hear Marvin, faced with this warm appreciation, saying, "Well, I got under her skin, didn't I?" or something equally casual. But an artist feels deeply appreciative when a stranger, far off, expresses a reaction.

An exhibit which must have brought a special feeling of happiness to Marvin was that held in 1957 by the Phoenix Art Center, a new museum whose founding director was Dr. Forrest M. Hinkhouse, a former student of Marvin's who was graduated from Coe College in 1948. He received his master's degree in art from New York University and his doctorate from the University of Madrid, Spain. He went to Phoenix from the University of Buffalo, where he had been assistant professor at the Albright Art School. The painting voted "most popular" at that exhibition was Marvin Cone's *Pennsylvania Barn*, which was on extended loan to the center.

143

Heritage

During all the years of recognition and acceptance in prominent art centers, Marvin was never neglected by the Art Association. His works were shown frequently, in the Little Gallery and later in the gallery at the Public Library. And Marvin was very active in the Art Association, to which he literally gave his life.

For Marvin and for the association, it was a labor of love on both sides. Marvin and Grant felt there was little enough they could do to repay the association for that act, so important to them, of exhibiting their pictures. Besides exhibiting and helping with the exhibits of the work of others, he was often called upon to "talk a painting." When the association bought a Karl Hofer painting for its own collection, Marvin was called upon to "explain it" for the viewing audience.

The painting, *Conservation,* was, he said:

A daring move into modernism, a liberal gesture in that direction. Karl Hofer belongs to the German expressionist group whose most obvious characteristic is intensity of both emotional and constructive qualities. For them, then, color is an important factor. Technical polish is of value to the dilettante craftsman rather than to the artist. Hofer shows the influence of Cezanne, Picasso, and Derain. Last year he won the highest possible award at the Carnegie, for *The Wind.* Never before from there have first honors gone to a German painter. . . .

We, in our Association, are inclined to be conservative in our collecting and ownership, so *Conversation* is focusing attention, happily, on those qualities which apply to the field of art, rather than to the realm of nature.

To this community, the most valuable painting ever lent was *American Gothic,* from the Art Institute of Chicago, its

144

permanent home. It has only been exhibited "at home" twice before, and the chances are that it will never be allowed out again, as it is getting old and fragile. It happened to be the first painting to arrive, the first to be unpacked so carefully and lovingly by the painter's great and close friend, Marvin Cone.

Marvin always hoped Cedar Rapids would some day have its own art museum. More than thirty years ago, he wrote:

> I see a white stone structure for us, occupying the center of a carefully selected city block . . . well-lighted galleries for permanent display of the growing collection of the Art Association, rooms for the hanging of passing exhibits (a real need in this city), a fair-sized lecture room, well-equipped studio for free Saturday classes in drawing and painting and several smaller rooms which will be furnished in authentic Iowa style through gifts of furniture by Cedar Rapids' pioneer families, valuable historic material for the future. If the city had a permanent exhibit place, some of this material would be available now.
>
> A small, beautifully designed building with limited but first class exhibitions is of far greater worth to any city than a vast structure filled with mediocre material. Any duly authorized board of directors, capable, non-political, could be in charge of the management of such a civic enterprise. Upkeep would be taken care of in a large measure by an Iowa law which permits cities the size of Cedar Rapids to devote a certain small percentage of its tax income for such a purpose.

Marvin Cone retired from his office in the Art Association in 1963. He was ill with a brain tumor for which he underwent surgery, and returned home. But he went back to the hospital, and in May, 1965, he died.

His services were held, fittingly, in the Coe College chapel and conducted by Dr. Joseph McCabe, president of the college. He was buried in Oak Hill, the old cemetery on the east side of the city. The house where he was born is almost across the street, just a door or two down on Seventeenth Street.

The *Coe Cosmos* honored the college's beloved teacher and artist in its issue of May 20, 1965. The article reviewed the facts of his life, his service to the college, his many honors. It also printed, as a tribute to Marvin, the following poem written in 1964 by "an admiring colleague":

To Dauber

You, dauber, with your palette and your brush,
The artist's eye and sensibility
That catches Iowa skies in dawning hush,
Red barns and corn fields in fertility.
To go with you along a peaceful road
To Waubeek, or perhaps to see a house
Long empty, bleak, no treasures here to hoard,
Just memories. Alone the humble mouse
Would know the beauty of old doors. But you
Give us the scenes on canvas. Fancy clowns,
Or streaks of grays and sometimes darker hues,
That give the viewer's face a smile, or frown.
Yet midst it all your love of man is there
That etches beauty on the canvas bare.

The college announced the establishment of two memorial collections in honor of Marvin Cone. They are The Marvin Cone Collection and The Marvin Cone Alumni Collection, financed by a gift from J. W. Fisher of Marshalltown and the college's Margaret Pilcher Fund.

The Marvin Cone Collection went on exhibit at Coe College on June 6, 1965. It included 25 paintings done by Marvin between 1925 and 1963: *River Farm*, 1925; *Old Things*, 1930; *Plant with Nude*, 1930; *Educational Exhibit*, 1939; *Maestro*, 1940; *Roadside Farm*, 1941; *Little Bohemia*, 1941; *The Big Top*, 1941; *Intervals, #2*, 1941; *Uncle Ben*, 1942; *Strange Vigil*, 1947; *Dark Design*, 1949; *Landmark*, 1949; *Blue Areas*, 1954; *Night Shapes*, 1955; *Space Pattern #2*, 1956; *Three Doorways*, 1956; *Blue Print for Fisherman*, 1956; *Blue and Grey Patterns*, 1957; *Housing Problem #3*, 1959; *Three Pears*, 1961; *Shadowed Door #2*, 1961; *Golden Segments*, 1962; *Singular Abode*, 1963; *Shapes on Shapes*, 1963.

The Marvin Cone Alumni Collection includes the work of his former pupils. Five from Cedar Rapids who are represented are Mrs. Wayne K. Cooper, Elizabeth Herzog Veley, Al Kuchera, Adeline Taylor Vavra, and Frank Kinney. The others are: Mrs. Herbert Gerstman, Marion, Iowa; Conger Metcalf, Boston; Zora DuVall, Lake Forest, Illinois; Eleanor Christensen Andreas, Rockford, Illinois; Gladys Arne Holton, Brooklyn; Dean Laubenheimer, North Hollywood; Byron McKeeby, New Orleans; Kitty Van Meter Sadick, Albuquerque; and Marion Martin Dickes, San Diego.

146

Still another memorial was a special booklet prepared by the college and designed by Richard Pinney of the Coe administrative staff, himself an artist of whom Marvin was fond. The pamphlet lists the two collections, with reproductions of some of the paintings and a picture of Marvin. There are brief tributes from some of his friends and associates.

Marvin's good friend, poet Paul Engle, wrote:

> He deserves the highest praise we can give an artist: The Art Is As Good As The Man. This exhibition demonstrates the process of one artist discovering his own personal way of transfiguring the merely visual into the vision. He had the painter's second sight, the form seen once and then again after the imagination had defined it. The whole man goes into the whole artist. Talent will take an individual only so far. After that, the suffering of talent with character, in all of its meanings, alone can create a superb art . . . Marvin Cone produced an art of honesty and insight.

Visiting recently with Arnold Pyle and his wife, Ruby, I asked him to tell me what he thought of Marvin Cone. "Marvin Cone was a quiet man," he said, "and in some ways rather a quiet painter. His was the under- rather than the over-statement, the subtle rather than the obvious."

Still another collection of Marvin Cone paintings exists in Cedar Rapids, for the Cones' little yellow house holds his scrapbooks and sketchbooks, and is filled with his paintings. "They belong," Winnifred will tell you, "to his grandchildren, willed to them." She is just the caretaker.

The feeling of the community at Marvin's death was perhaps best expressed by an editorial in the Cedar Rapids *Gazette:*

> It may be many years before the gap in the cultural assets left by the death of Marvin Cone will be filled again. Men, and artists, of his caliber, do not come along frequently. Any community can consider itself fortunate to number among its residents a creative artist of his nationally recognized stature, if only for the advantage of ready and continuing access to a broad spectrum of his work. The many Marvin Cone paintings in the Cedar Rapids area will be treasured increasingly with the passing years for the aesthetic satisfaction and emotional stimulation inherent in them.
>
> But Cedar Rapids' good fortune was infinitely greater in that Marvin's contribution to the community went far and beyond what he put on canvas. Unlike many good artists, he was not only a master of his craft but also an interpreter of his art, art of the first order. In fact, in his modesty, he seemed almost to subordinate his own work to a

lifetime effort to foster a wider appreciation of all art among the uninitiated. His ability to do this stemmed from his character as a man, his kindly manner, his warm understanding of people of all types among whom he lived.

Neither culture nor art stops because its most brilliant exponents are no longer here. The Cedar Rapids Art Center continues to live up to its traditions and its time.

Marvin outlined what he believed the community needed by way of a proper art center. After his retirement, the association decided that matters had come to a head, that new quarters were imperative. A committee was appointed to look for a site for a new home.

A short way from the heart of the downtown district, many years ago, a sturdy building had been erected, four floors high, to house a publishing business, The Torch Press. The business was gone; the building, with the growth of the city beyond it, found itself on a busy downtown corner, important enough to have a traffic light.

The committee, which included an "old" architect and a "young" architect, took a long look at the square, red brick building, tramped through the insides of it and decided that the "shell" would do. The inside, however, would have to be gutted and remodeled. They found enough contributors to make the start.

The entire outside of the building was painted white. The inside was indeed gutted. Except for partitioning off service areas, the first two floors were great open spaces, with windows to the east, folding shutters, modern museum lighting, and walls fit for *hanging*. Glass doors framed in black steel opened onto the entrance lobby. The committee went as far as it could with the money on hand, doing it well, rather than doing a makeshift job for the sake of finishing the entire building. They felt that Grant and Marvin would approve.

The opening, the invitations, the first drive for membership is a story of dust, sawing, pounding, with people working in the lobby of the building even as the carpenters and finishers went on with their work. The move from the Public Library gallery, just two blocks away, was made, and the center was opened

148

and dedicated in June, 1964. Marvin was far too ill to attend.

The first floor gallery was named the Grant Wood Gallery. On the second floor, the duplicate space was named the Marvin Cone Gallery, and the motion to do that stated: "For a lifetime of service . . . and so naming it in his honor that all future generations shall know in what high regard and esteem his memory is held." A Memorial Fund was established at the same time, to continue the work on the art center.

In the fall of 1967, a gift to the art center from the Stamats family completed another piece in the overall plan. The Herbert S. Stamats Memorial Art Library was opened, with a good collection of art books and periodicals that continues to grow as the art center continues to grow.

Through the years, people have been astonished at the accrued value of the paintings owned by the association. As early as 1937, the permanent collection included *The Holy Women,* by H. O. Tanner, still regarded as one of the finest paintings in the collection; and *Captain, Cook and First Mate,* by Charles Hawthorne, which was purchased for $8,500. Grant Wood's *Woman with Plant* was purchased for $300, and Marvin said before his death it was worth at least $10,000. And especially prized is *Allegory of Peace,* by Jakub Obrovsky, which was bought for the collection by Czech members of the community.

Other paintings by Grant and paintings by Marvin are in the permanent collection, and many are hung in the homes and business places of Cedar Rapids. It has been estimated that about two hundred Cone paintings are owned locally, all of them, as Marvin used to say, "on permanent exhibit."

On Labor Day in 1962, a little more than twenty years after the death of Grant Wood, the Art Association opened an exhibit of his work which ran for three weeks. Approximately seventy paintings and drawings were shown, including a rare one, sketched by Grant of himself when he was a patient at St. Luke's hospital in 1919, which he called *The Green Eyed Monster.*

In its corporate and private ownership, Cedar Rapids has, of course, as a "collection," the most and some of the best of Grant Wood's work. An exhibit of these locally owned paintings was held at the art center in 1969. Included were *Ten Tons of*

Accuracy and the portraits of Mary and Susan Shaffer. There were also ten works owned by the Cedar Rapids Community School District.

Also, in 1969, Marvin's work was exhibited at the art center. Donn Young, the director, was so interested in the paintings which came in for this exhibit that he asked Winnifred's permission to exhibit, in a later show, the work from Marvin's sketch books.

This exhibit, beautifully arranged by Donn, gave the viewer an idea of what Marvin really did when he got home from sketching or looking at people and scenery. Here was pencil drawing, crayon drawing, and in many cases, the finished oil painting developed from them. This progression brought many noses close to the exhibit pieces to *see*, to realize, the work, the detail, the patience, that contributed to the final finished oil.

I saw this exhibit with Winnifred. When we were ready to leave, I said to her, "Winnifred, this is a wonderful and unusual exhibit!"

She replied, with her voice full of admiration, "Yes, it is. Donn Young did a beautiful job of selecting the sketches and arranging them in this way." And she whispered, "I never get tired of seeing them."

A decade later, in the spring of 1972, the art center presented "Grant Wood—the Graphic Works" as part of its continuing dedication to preserving the Wood-Cone heritage. Donn Young has said: "I think Grant and Marvin would approve of the flexibility of the art center today, its new directions; old directions in a new light; people talking, learning, living, growing, changing—for certainly Marvin and Grant were both intimately involved in the art of change."

Years ago, it was predicted that once a younger generation took over the family homes, or built new, modern ones, they would be buying "modern" art, and we would see the old Wood and Cone paintings up for sale. But people who have come here with money in pocket trying to get hold of a Wood or Cone original have found that no amount of prying—or cash—has been able to do it.

150